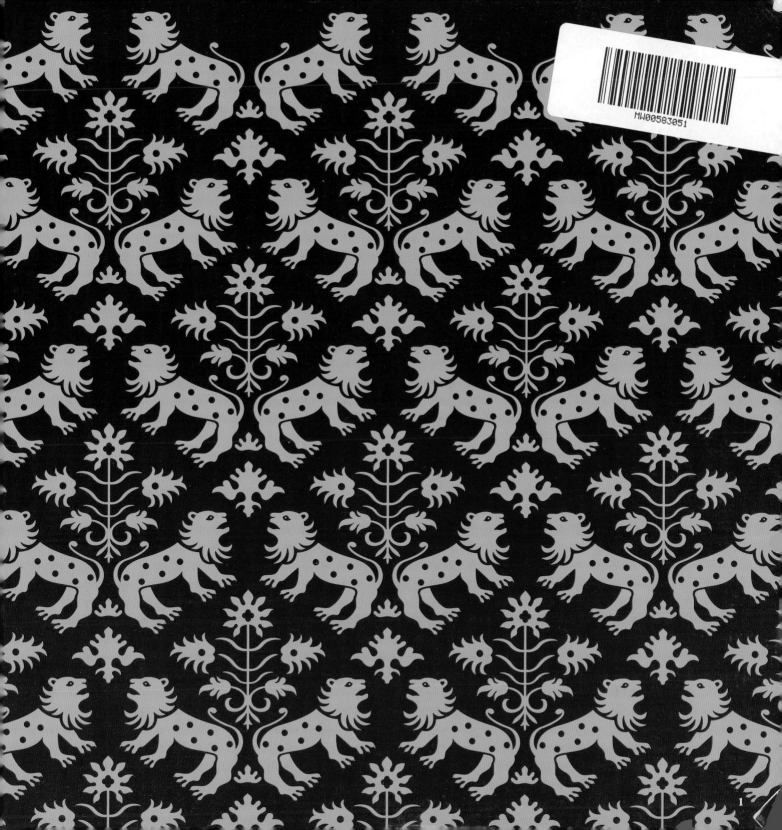

1

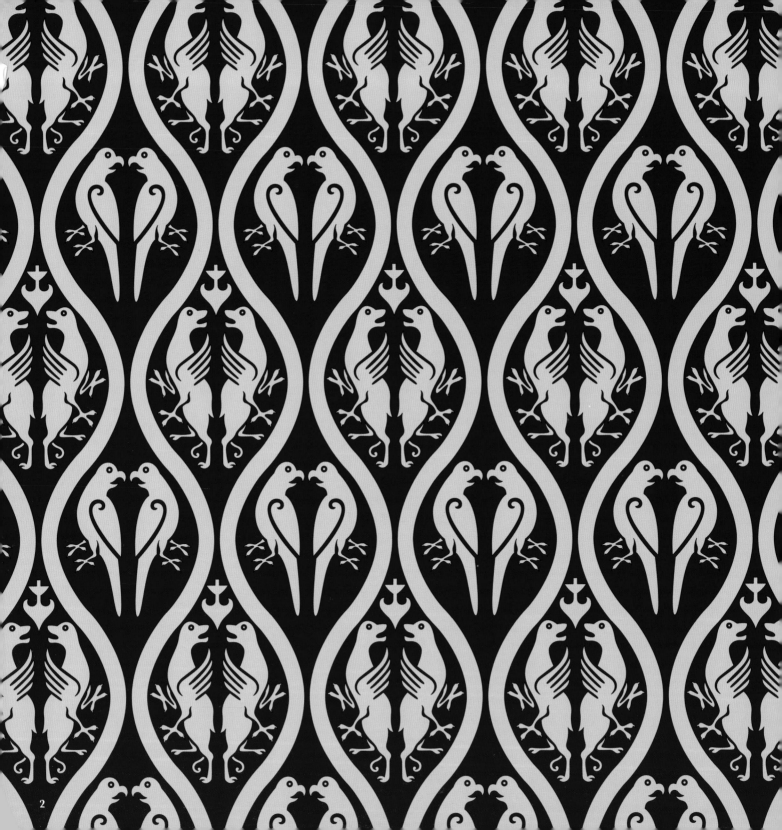

Tapestry

TAPISSERIE
TAPISSERIEN
TAPICERÍA
ARAZZI
TAPEÇARIA
ГОБЕЛЕНЫ
织锦画・タペストリー

The Pepin Press | Agile Rabbit Editions

The Pepin Press | Agile Rabbit Editions publishes a wide range of books on art, design, architecture, applied art, fashion and popular culture.

For a complete list of available titles, please visit our website at: **www.pepinpress.com**

The following is a selection of the titles available from our website or at your local bookseller.

Weaving Patterns
Lace
Embroidery
Ikat Patterns
Batik Patterns
Textile Motifs of India
Fabric Textures & Patterns

Floral Patterns
Wallpaper Designs
Watercolour Patterns
Marbled Paper Designs
Historical & Curious Maps

Chinese Patterns
Japanese Patterns
Turkish Designs
Persian Designs
Islamic Designs
Islamic Designs from Egypt
Arabian Geometric Patterns

Traditional Dutch Tile Designs
Barcelona Tile Designs
Tile Designs from Portugal
Havana Tile Designs

Mediæval Patterns
Gothic Patterns
Renaissance Patterns
Baroque Patterns
Rococo Patterns
Repeating Patterns 1300–1800

Art Nouveau Designs
Jugendstil
Art Deco Designs
Fancy Designs 1920
Patterns of the 1930s

Images of the Universe
Female Body Parts
Fruit
Vegetables

Fancy Alphabets
Signs & Symbols
1000 Decorated Initials

How To Fold
Folding Patterns for Display & Publicity
Structural Package Designs
Special Packaging
Take One!

Web Design Index
Web Design Index by Content

Figure Drawing for Fashion Design
Wrap & Drape Fashion
Fashion Design 1800-1940
Art Deco Fashion

Ethnic Jewellery
Crown Jewellery

Colophon

Contents

The Pepin Press | Agile Rabbit Editions
P.O. Box 10349
1001 EH Amsterdam, The Netherlands

Tel +31 20 420 20 21
Fax +31 20 420 11 52
mail@pepinpress.com
www.pepinpress.com

Design & text by Pepin van Roojen

Picture scanning and restoration by
Jakob Hronek

ISBN 978 90 5768 113 4

10 9 8 7 6 5 4 3 2 1
2012 11 10 09 08

Manufactured in Singapore

Introduction in English	9
Introduction en français	11
Einleitung auf Deutsch	13
Introducción en español	15
Introduzione in italiano	17
Introdução em português	19
Введение на русском языке	21
日本語による序文	23
中文简介	25

Free CD-Rom inside the back cover

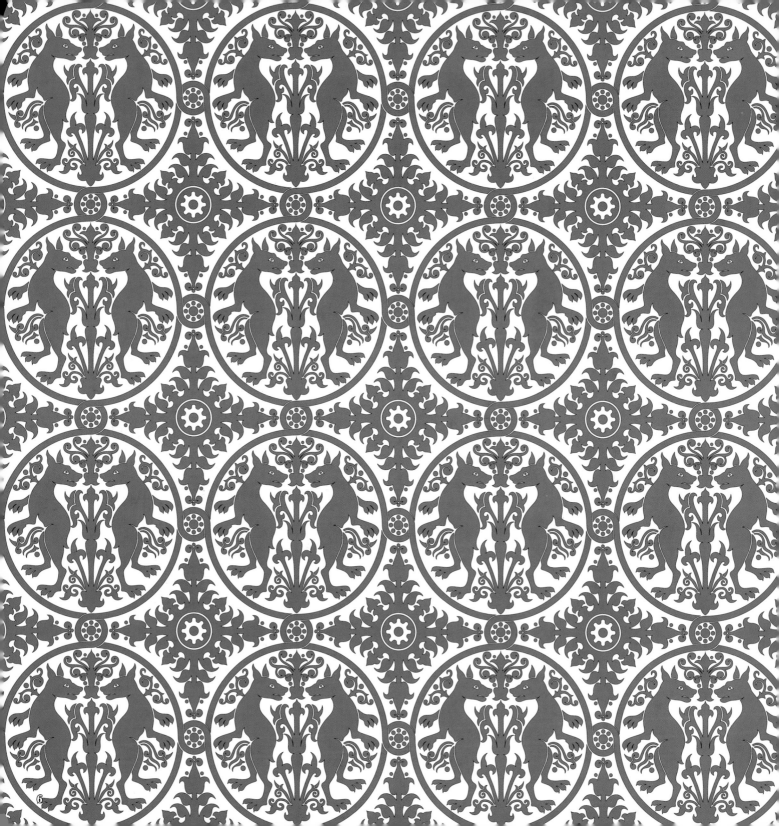

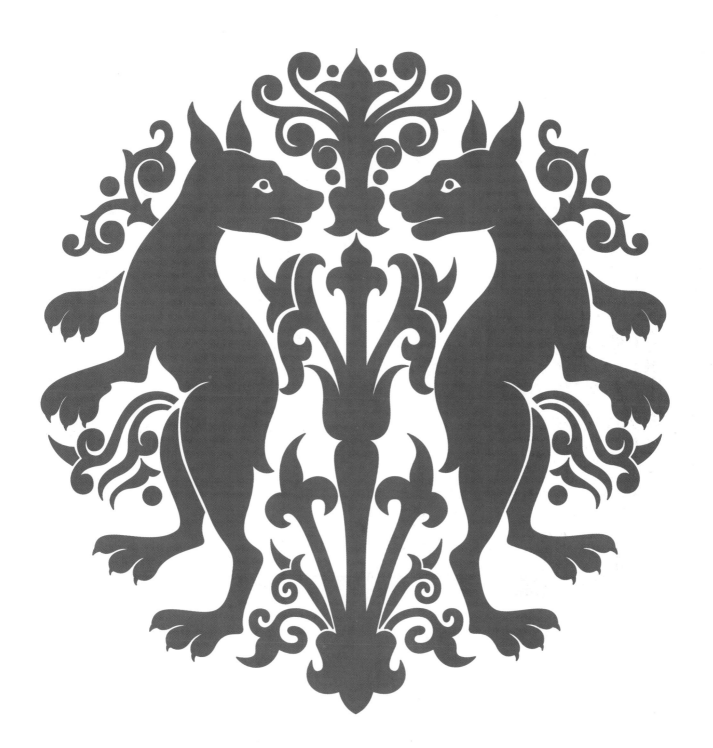

page 1

page 1

page 2

page 6

page 6

page 24

page 26

page 26

page 27

Tapestry

From the 14th to 17th centuries the art of weaving thick fabrics with beautifully executed designs flourished, particularly in Flanders and Northern France, and to a lesser extent in Germany and Italy. The tapestries made in and around Arras, Lille, Brussels, Florence and other major textile towns were sought after to decorate palaces, castles, churches and grand houses throughout Europe.

Unlike in other weaving forms, in true tapestry mostly the weft threads are visible, as these are applied back and forth to create the desired design and often completely cover the warp. Tapestry can only be created by hand, and master weavers were able to execute extremely intricate designs. This book contains more than a hundred repeat patterns from Medieval, Renaissance and Baroque tapestries, all carefully reproduced and included on the accompanying CD.

CD-ROM & Image Rights

The images in this book can be used as a graphic resource and for inspiration. All the illustrations are stored on the enclosed CD-ROM and are ready to use for printed media and web page design. The pictures can also be used to produce postcards, either on paper or digitally, or to decorate your letters, flyers, T-shirts, etc. They can be imported directly from the CD into most software programs. Some programs will allow you to access the images directly; in others, you will first have to create a document, and then import the images. Please consult your software manual for instructions.

The names of the files on the CD-ROM correspond with the page numbers in this book. The CD-ROM comes free with this book, but is not for sale separately. The files on Pepin Press/Agile Rabbit CD-ROMs are sufficiently large for most applications. However, larger and/or vectorised files are available for most images and can be ordered from The Pepin Press/Agile Rabbit Editions.

For non-professional applications, single images can be used free of charge. The images cannot be used for any type of commercial or otherwise professional application – including all types of printed or digital publications – without prior permission from The Pepin Press/Agile Rabbit Editions. Our permissions policy is very reasonable and fees charged, if any, tend to be minimal.

For inquiries about permissions and fees, please contact:
mail@pepinpress.com
Fax +31 20 4201152

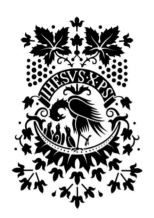

page 28

page 29

page 32

page 32

page 32

page 34

page 35

page 35

page 35

Tapisserie

Du XIVᵉ au XVIIᵉ siècle, l'art de tisser d'épaisses étoffes aux motifs magnifiquement exécutés était en plein essor, particulièrement en Flandre et dans le Nord de la France, et à un degré moindre en Allemagne et en Italie. Les tapisseries fabriquées à Arras, à Lille, à Bruxelles, à Florence et dans d'autres villes textiles étaient recherchées pour décorer les palais, les châteaux, les églises et les grandes maisons à travers l'Europe. Contrairement aux autres techniques de tissage, dans la tapisserie véritable les fils de trame sont généralement visibles, parce qu'ils sont appliqués en va-et-vient pour créer le motif désiré et recouvrent souvent entièrement la chaîne. La tapisserie peut être créée uniquement à la main et les maîtres-tisserands étaient capables d'exécuter des motifs extrêmement élaborés. Ce livre contient plus d'une centaine de motifs de tapisserie du Moyen Âge, de la Renaissance et du Baroque, toutes soigneusement reproduites et incluses sur le CD-ROM d'accompagnement.

CD-ROM et droits d'auteur

Les images contenues dans ce livre peuvent servir de ressources graphiques ou de source d'inspiration. Toutes les illustrations sont stockées sur le CD-ROM ci-joint et sont prêtes à l'emploi sur tout support imprimé ou pour la conception de site Web. Elles peuvent également être employées pour créer des cartes postales, en format papier ou numérique, ou pour décorer vos lettres, prospectus, T-shirts, etc. Ces images peuvent être importées directement du CD dans la plupart des logiciels. Certaines applications vous permettent d'accéder directement aux images, tandis que d'autres requièrent la création préalable d'un document pour pouvoir les importer. Veuillez vous référer au manuel de votre logiciel pour savoir comment procéder.

Les noms des fichiers du CD-ROM correspondent aux numéros de page de cet ouvrage. Le CD-ROM est fourni gratuitement avec ce livre, mais ne peut être vendu séparément. Les fichiers des CD-ROM de The Pepin Press/Agile Rabbit sont d'une taille suffisamment grande pour la plupart des applications. Cependant, des fichiers plus grands et/ou vectorisés sont disponibles pour la plupart des images et peuvent être commandés auprès des éditions The Pepin Press/Agile Rabbit.

Pour en savoir plus sur les autorisations et les droits d'auteur, veuillez contacter :
mail@pepinpress.com
Fax +31 20 4201152

page 40

page 44

page 45

page 48

page 49

page 52

page 58

page 59

page 64

Tapisserien

Die Kunst der Tapisserie - die Herstellung von aufwändigen Wandteppichen mit wundervoll ausgeführten Wirkbildern - erlebte zwischen dem 14. und dem 17. Jahrhundert insbesondere in Flandern und Nordfrankreich, aber auch in Deutschland und Italien ihre Blütezeit. Die in Arras, Lille, Brüssel, Florenz und anderen bedeutenden Textilhochburgen gefertigten Wandteppiche waren gefragte Dekorationsobjekte und schmückten Paläste, Burgen, Kirchen und Herrenhäuser in ganz Europa.

Im Gegensatz zu anderen Webtechniken sind bei echten Tapisserien die Schussfäden meistens sichtbar, da diese vor- und zurückgeführt werden, um das gewünschte Bild zu erzeugen, und die Kettfäden oft vollständig verdecken. Echte Tapisserien werden immer von Hand gefertigt, und nur erfahrene Meisterweber sind in der Lage, die meist extrem komplizierten und kunstvollen Bilder umzusetzen.

Dieses Buch enthält über einhundert wiederkehrende Tapisseriedesigns aus dem Mittelalter, der Renaissance und dem Barock, die auf der beiliegenden CD-ROM sorgfältig reproduziert wurden.

CD-ROM und Bildrechte

Dieses Buch enthält Bilder, die als Ausgangsmaterial für grafische Zwecke oder als Anregung genutzt werden können. Alle Abbildungen sind auf der beiliegenden CD-ROM gespeichert und lassen sich direkt zum Drukken oder zur Gestaltung von Webseiten einsetzen. Sie können die Designs aber auch als Motive für Postkarten (auf Karton bzw. in digitaler Form) oder als Ornament für Ihre Briefe, Broschüren, T-Shirts usw. verwenden. Die Bilder lassen sich direkt von der CD in die meisten Softwareprogramme laden. Bei einigen Programmen lassen sich die Grafiken direkt einladen, bei anderen müssen Sie zuerst ein Dokument anlegen und können dann die jeweilige Abbildung importieren. Genauere Hinweise dazu finden Sie im Handbuch Ihrer Software. Die Namen der Bilddateien auf der CD-ROM entsprechen den Seitenzahlen dieses Buchs. Die CD-ROM wird kostenlos mit dem Buch geliefert und ist nicht separat verkäuflich. Alle Bilddateien auf den CD-ROMs von The Pepin Press/Agile Rabbit wurden so groß dimensioniert, dass sie für die meisten Applikationen ausreichen; zusätzlich können jedoch größere Dateien und/oder Vektorgrafiken der meisten Bilder bei The Pepin Press/Agile Rabbit Editions bestellt werden.

Einzelbilder dürfen für nicht-professionelle Anwendungen kostenlos genutzt werden; dagegen muss für die Nutzung der Bilder in kommerziellen oder sonstigen professionellen Anwendungen (einschließlich aller Arten von gedruckten oder digitalen Medien) unbedingt die vorherige Genehmigung von The Pepin Press/Agile Rabbit Editions eingeholt werden. Allerdings handhaben wir die Erteilung solcher Genehmigungen meistens recht großzügig und erheben – wenn überhaupt – nur geringe Gebühren.

Für Fragen zu Genehmigungen und Preisen wenden Sie sich bitte an:
mail@pepinpress.com
Fax +31 20 4201152

page 64

page 70

page 71

page 74

page 75

page 78

page 79

page 79

page 84

Tapicería

Entre los siglos XIV y XVII, especialmente en Flandes y el norte de Francia y, en menor medida, en Alemania e Italia, floreció el arte de tejer gruesas telas con diseños primorosamente aplicados. Los tapices creados en Arras, Lille, Bruselas, Florencia y otras ciudades con una importante tradición textil eran muy buscados para decorar palacios, castillos, iglesias y mansiones de toda Europa.

A diferencia de otras técnicas de tejeduría, en general la tapicería auténtica se caracteriza por la visibilidad de los hilos de la trama, que se aplican en varias direcciones para obtener el diseño deseado y, a menudo, cubren la urdimbre por completo. Los tapices solo pueden crearse manualmente, y los maestros tapiceros lograban diseños verdaderamente intrincados. Este libro incluye más de un centenar de motivos repetitivos de tapices medievales, renacentistas y barrocos, todos ellos reproducidos al detalle e incluidos en el CD adjunto.

CD-ROM y derechos sobre las imágenes

Este libro contiene imágenes que pueden servir como material gráfico o simplemente como inspiración. Todas las ilustraciones están incluidas en el CD-ROM adjunto y pueden utilizarse en medios impresos y diseño de páginas web. Las imágenes también pueden emplearse para crear postales, ya sea en papel o digitales, o para decorar sus cartas, folletos, camisetas, etc. Pueden importarse directamente desde el CD a diferentes tipos de programas. Algunas aplicaciones informáticas le permitirán acceder a las imágenes directamente, mientras que otras le obligarán a crear primero un documento y luego importarlas. Consulte el manual de software pertinente para obtener instrucciones al respecto.

Los nombres de los archivos contenidos en el CD-ROM se corresponden con los números de página del libro. El CD-ROM se suministra de forma gratuita con el libro. Queda prohibida su venta por separado. Los archivos incluidos en los discos CD-ROM de Pepin Press/Agile Rabbit tienen una resolución suficiente para su uso con la mayoría de aplicaciones. Sin embargo, si lo precisa, puede encargar archivos con mayor definición y/o vectorizados de la mayoría de las imágenes a The Pepin Press/Agile Rabbit Editions.

Para aplicaciones no profesionales, pueden emplearse imágenes sueltas sin coste alguno. Estas imágenes no pueden utilizarse para fines comerciales o profesionales (incluido cualquier tipo de publicación impresa o digital) sin la autorización previa de The Pepin Press/Agile Rabbit Editions. Nuestra política de permisos es razonable y las tarifas impuestas tienden a ser mínimas.

Para solicitar información sobre autorizaciones y tarifas, póngase en contacto con:
mail@pepinpress.com
Fax +31 20 4201152

page 84

page 84

page 84

page 84

page 84

page 84

page 84

page 85

page 85

Arazzi

Dal XIV al XVII secolo fiorì l'arte di intrecciare tessuti spessi e di realizzare splendidi disegni. Questa tecnica si diffuse in particolar modo nelle Fiandre e nella Francia settentrionale, in misura minore in Germania e in Italia. Gli arazzi fatti nelle zone di Arras, Lille, Bruxelles, Firenze e in varie altre città in cui fiorì questa arte, erano molto richiesti per la decorazione di palazzi, castelli, chiese e dimore di personaggi importanti in tutta l'Europa. Diversamente da quanto accade con altre tecniche di tessitura, nell'arazzo i fili della trama sono quasi sempre visibili, poiché sono applicati davanti e didietro per creare il motivo desiderato e spesso coprire interamente l'ordito. Gli arazzi possono essere fatti solamente a mano ed i maestri tessitori erano in grado di eseguire dei disegni estremamente complicati. Questo libro contiene le riproduzioni di più di cento motivi ripresi da arazzi medievali, rinascimentali e barocchi, ricostruiti in maniera attenta e inclusi nel CD allegato.

CD-ROM e diritti d'immagine

Le immagini contenute in questo libro possono essere utilizzate come risorsa grafica e come ispirazione. Tutte le illustrazioni sono salvate sul CD ROM incluso e sono pronte ad essere utilizzate per la stampa su qualsiasi tipo di supporto e per il design di pagine web. Le immagini possono anche essere utilizzate per produrre delle cartoline, in forma stampata o digitale, o per decorare le vostre lettere, volantini, magliette, eccetera. Possono essere direttamente importate dal CD nella maggior parte dei programmi software. Alcuni programmi vi permetteranno l'accesso diretto alle immagini; in altri, dovrete prima creare un documento, e poi importare le immagini. Vi preghiamo di consultare il manuale del vostro software per ulteriori istruzioni.
I nomi dei file sul CD ROM corrispondono ai numeri di pagina indicati nel libro. Il CD ROM viene fornito gratis con il libro, ma non è in vendita separatamente. I file sui CD ROM della Pepin Press/Agile Rabbit sono di dimensione adatta per la maggior parte delle applicazioni. In ogni caso, per la maggior parte delle immagini sono disponibili file più grandi o vettoriali, che possono essere ordinati alla Pepin Press/Agile Rabbit Editions. Delle singole immagini possono essere utilizzate senza costi aggiuntivi a fini non professionali. Le immagini non possono essere utilizzate per nessun tipo di applicazione commerciale o professionale – compresi tutti i tipi di pubblicazioni stampate e digitali – senza la previa autorizzazione della Pepin Press/Agile Rabbit Editions. La nostra gestione delle autorizzazioni è estremamente ragionevole e le tariffe addizionali applicate, qualora ricorrano, sono minime.

Per ulteriori domande riguardo le autorizzazioni e le tariffe, vi preghiamo di contattarci ai seguenti recapiti:
mail@pepinpress.com
Fax +31 20 4201152

page 85

page 85

page 85

page 85

page 85

page 96

page 96

page 97

page 102

Tapeçaria

Do século XIV ao século XVII, a arte de produzir tecidos grossos com desenhos soberbamente executados prosperou, em especial na Flandres e no Norte de França, mas também na Alemanha e na Itália, embora com menor expressão. As tapeçarias produzidas em Arras, Lille, Bruxelas, Florença e noutras grandes cidades têxteis, bem como nos seus arredores, eram cobiçadas para decorar palácios, castelos, igrejas e casas senhoriais por toda a Europa.

Ao contrário de outras técnicas de tecelagem, na tapeçaria autêntica são sobretudo os fios da trama que estão à vista, pois são aplicados sucessivamente para criar o desenho pretendido e, muitas vezes, cobrem a teia por completo. A tapeçaria só pode ser feita à mão e os mestres-tecelões conseguiam executar desenhos extremamente elaborados. Este livro contém mais de uma centena de módulos de repetição de tapeçarias medievais, renascentistas e barrocas, todos cuidadosamente reproduzidos e incluídos no CD que acompanha o livro.

CD-ROM e direitos de imagem

As imagens neste livro podem ser usadas como recurso gráfico e fonte de inspiração. Todas as ilustrações estão guardadas no CD-ROM incluído e prontas a serem usadas em suportes de impressão e design de páginas web. As imagens também podem ser usadas para produzir postais, tanto em papel como digitalmente, ou para decorar cartas, brochuras, T-shirts e outros artigos. Podem ser importadas directamente do CD para a maioria dos programas de software. Alguns programas permitem aceder às imagens directamente, enquanto que noutros, terá de primeiro criar um documento para poder importar as imagens. Consulte o manual do software para obter instruções.

Os nomes dos ficheiros no CD-ROM correspondem aos números de páginas no livro. O CD-ROM é oferecido gratuitamente com o livro, mas não pode ser vendido separadamente. A dimensão dos ficheiros nos CD-ROMs da Pepin Press/Agile Rabbit é suficiente para a maioria das aplicações. Contudo, os ficheiros maiores e/ou vectorizados estão disponíveis para a maioria das imagens e podem ser encomendados junto da Pepin Press/Agile Rabbit Editions.

Podem ser usadas imagens individuais gratuitamente no caso de utilizações não profissionais. As imagens não podem ser usadas para qualquer tipo de utilização comercial ou profissional, incluindo todos os tipos de publicações digitais ou impressas, sem autorização prévia da Pepin Press/Agile Rabbit Editions. A nossa política de autorizações é muito razoável e as tarifas cobradas, caso isso se aplique, tendem a ser bastante reduzidas.

Para esclarecimentos sobre autorizações e tarifas, queira contactar:
mail@pepinpress.com
Fax +31 20 4201152

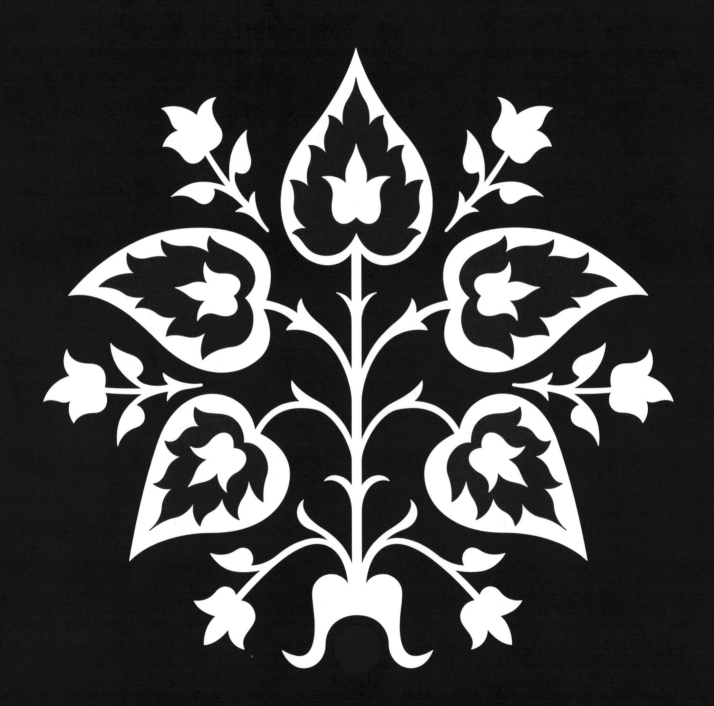

Гобелены

Искусство ткачества толстых тканей с прекрасно исполненными картинами процветало с XIV до XVII века, особенно во Фландрии и Северной Франции, и в меньшей степени в Германии и Италии. Гобелены, сделанные в Аррасе, Лилле, Брюсселе, Флоренции и других крупных текстильных городах, пользовались огромным спросом, ими украшали дворцы, замки, церкви и дома знати по всей Европе. В отличие от других видов ткачества, в настоящих гобеленах уточная нить чаще всего видна, поскольку она прокидывается как вперед, так и назад, создавая нужный рисунок и обычно полностью покрывая основу. Гобелены ткали исключительно вручную, и мастера могли воспроизводить чрезвычайно сложные рисунки. В этой книге приводятся образцы картин средних веков, эпохи Возрождения и периода барокко. Представлены более ста изумительных картин, все они тщательно перерисованы и оцифрованы.

Авторские права на компакт-диск и изображения

Изображения, представленные в этой книге, можно использовать в качестве графического ресурса и как источник вдохновения. Все иллюстрации хранятся на прилагаемом компакт-диске. Их можно распечатывать и применять при разработке веб-страниц. Кроме того, иллюстрации можно использовать при изготовлении открыток, как на бумаге, так и цифровых, а также для украшения писем, рекламных материалов, футболок и т.д. Изображения можно непосредственно импортировать в большинство программ. В одних приложениях можно получить прямой доступ к иллюстрациям, в других придется сначала создать документ, а затем уже импортировать изображения. Конкретные рекомендации см. в руководстве по программному обеспечению.

Имена файлов на компакт-диске соответствуют номерам страниц этой книги. Компакт-диск прилагается к книге бесплатно, но отдельно он не продается. Файлы на компакт-дисках Pepin Press/Agile Rabbit достаточно велики для большинства приложений. Однако для многих изображений в The Pepin Press/Agile Rabbit Editions можно заказать и файлы большего объема или файлы векторизованных изображений.

В применениях непрофессионального характера отдельные изображения можно использовать бесплатно. Изображения нельзя использовать в любых видах коммерческих или других профессиональных применений – включая все виды печатной и цифровой публикации – без предварительного разрешения The Pepin Press/Agile Rabbit Editions. Наша политика выдачи разрешений достаточно обоснованна и расценки оплаты, если таковая вообще потребуется, обычно минимальны.

С запросами по поводу разрешений и оплаты обращайтесь:
mail@pepinpress.com
Факс +31 20 4201152

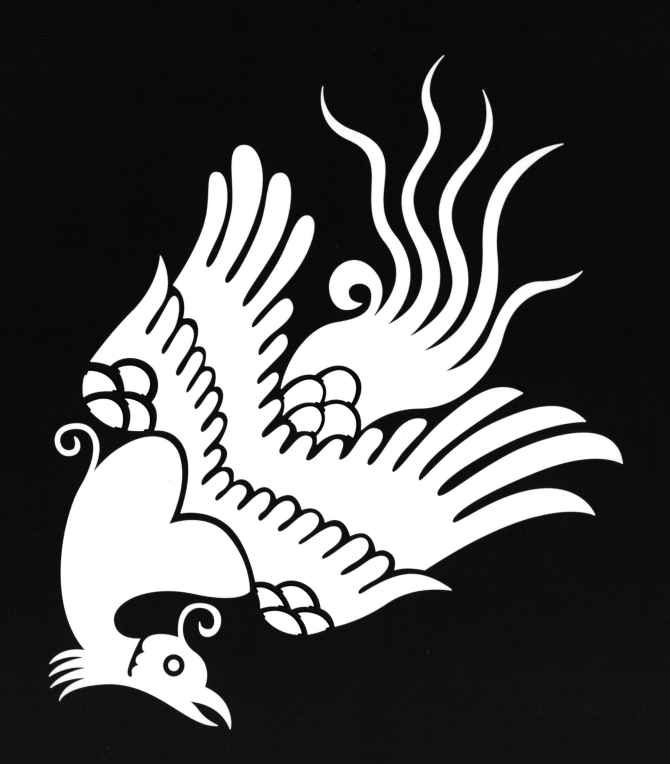

タペストリー

14世紀から17世紀にかけ、フランダースから北フランスに亘る地域で、重厚な布にすばらしいデザインを施す織物の技法が盛んに用いられるようになりました。この技法は、ドイツとイタリアでも一部に多少の広まりをみせました。アラス、リール、ブリュッセル、フローレンスなど、織物の町として栄えた地域の職人は、ヨーロッパ中の宮廷、城、教会、大邸宅などの装飾を任されるようになりました。

他の織物技術とは異なり、本格的なタペストリーでは、思いどおりのデザインを作るための横糸が表面に現れるよう織られており、デザインによっては縦糸が全く表面に見えないものもあります。タペストリーは全て手作業で製作されています。優れた職人の手によるタペストリーは、みごとなまでに複雑なデザイン的表現が織り込まれているものも少なくありません。本書には、中世、ルネサンス、およびバロック様式のタペストリーで使用されている100以上の繰返しパターンが収録されています。これらのパターンの画像は、付録のCDに収められています。

CD-ROM及びイメージの版権について

本書にイメージは、グラフィック・デザインの参考にしたり、インスピレーションを得るための材料としてご使用ください。付録のCD-ROMに収められたすべてのイラストは、すぐに印刷媒体やウェブデザインでご利用いただけます。イメージは、絵はがき、レター、チラシ、Tシャツなどの作成にも利用できます。ほとんどのソフトウエア・プログラムへ、CD-ROMから直接インポートが可能です。直接イメージにアクセスできない場合には、まずファイルを作成することで、ご使用になりたいイメージを簡単にインポートできます。インポートの方法などの詳細については、ソフトウエアのマニュアルをご参照ください。

D-ROMの各ファイル名は、本書のページ番号に対応していますこのCD-ROMは本書の附録であり、CD-ROMのみの販売はいたしておりません。Pepin Press/Agile RabbitのCD-ROM収録のファイルは、ほとんどのアプリケーションに対応できるサイズです。より大きなサイズのファイル、あるいはベクトル化されたファイルをご希望の方は、The Pepin Press/Agile Rabbit Editions宛てにご連絡ください。

イメージを非営利目的で使用する場合は、1画像のみ無料でご使用いただけます。印刷媒体、デジタル媒体を含む、業務や営利目的でのご使用の場合は、事前にThe Pepin Press/Agile Rabbit Editionsから許可を得ることが必要です。著作権料が必要となる場合でも最小限の料金でご提供させていただきます。

使用許可と著作権料については下記にお問い合わせください。
mail@pepinpress.com
ファックス：+31 20 4201152

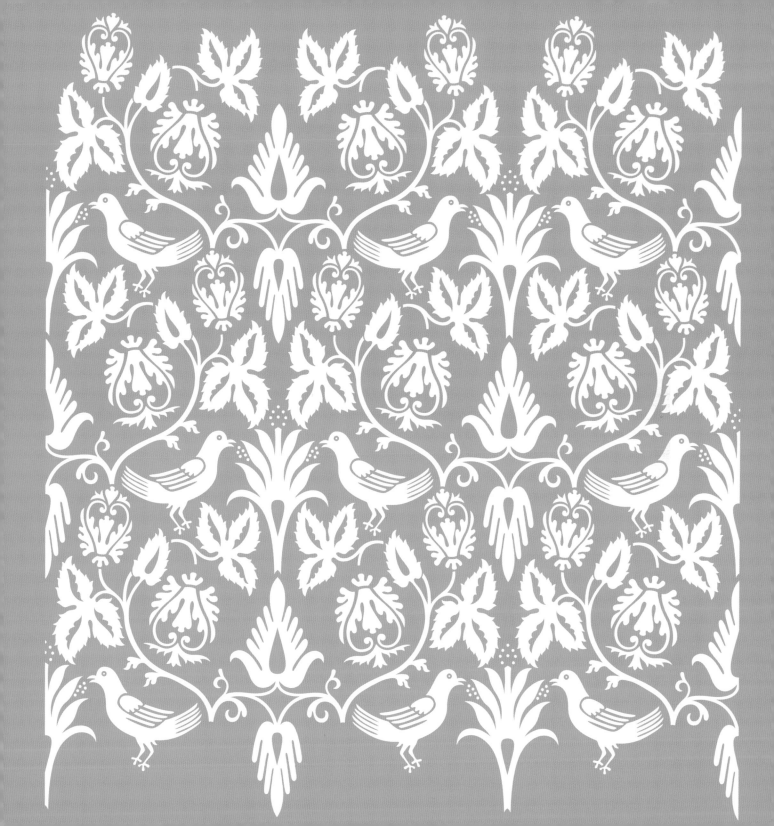

织锦画

在十四世纪至十七世纪期间，织锦画十分流行，这种在厚布料上织出美丽图案的手法一时蔚然成风，尤其在佛兰德斯和法国北部一带 (其次在德国和意大利) 极受欢迎。产自阿拉斯、里尔、布鲁塞尔、佛罗伦萨和其他主要生产布料的城镇的织锦画，需求极大，用以装饰欧洲各地的宫殿、城堡、教堂及达官贵人的府第。

真正的织锦画的纺织手法跟别的纺织技术并不一样。织造织锦画时，纬纱多是清晰可见的，因为在织造的过程中，纬纱是一针一针的绣下去以构成设计的图案，往往会把经线完全覆盖。织锦画只能以人手制造，纺织技术高超的大师能造出极复杂的设计图案。本书收集了一百多份图案式样，取材自中世纪、文艺复兴及巴洛克时期的织锦画作品，全部经过精心复制，储存在随书的 CD内。

CD-ROM及图像的版权

此书的图像可用作图形资源于以使用，亦可用以启发创作灵感。书中的所有配图均存储在所附的CD-ROM中，随时可用于刊物媒体及网页设计上。图像亦可用于制 作纸质或数字化的明信片，又或是用来装饰阁下的信件、宣传单张及T恤等。这些图像可以直接从CD-ROM输入到多数软件程式中。有些程式可以直接连接到图像；有些则要求阁下先创设一个文件，然后才输入图像。详情请参阅阁下的软件手册中的指示。

CD-ROM中的档案名称是跟本书的页码相对应的。CD-ROM随本书附送，并不得单独出售。The Pepin Press/Agile Rabbit Editions 出版的CD-ROM，载有的档案相当庞大，足以应付多数应用。不过，本社亦提供更大及/或矢量格式化的档案，请到The Pepin Press/Agile Rabbit Editions 选购。

单个图像可于非专业用途上免费使用。但在未经The Pepin Press/Agile Rabbit Editions事先许可的情况下，图像不能用于任何类型的商业或其他专业用途，当中包括所有类型的打印或数字化的刊物。本社订有一套合理的许可政策。若有收费的需要，所涉的金额亦通常是甚低微的。

有关许可及收费，请联系:
mail@pepinpress.com
传真: +31 20 4201152

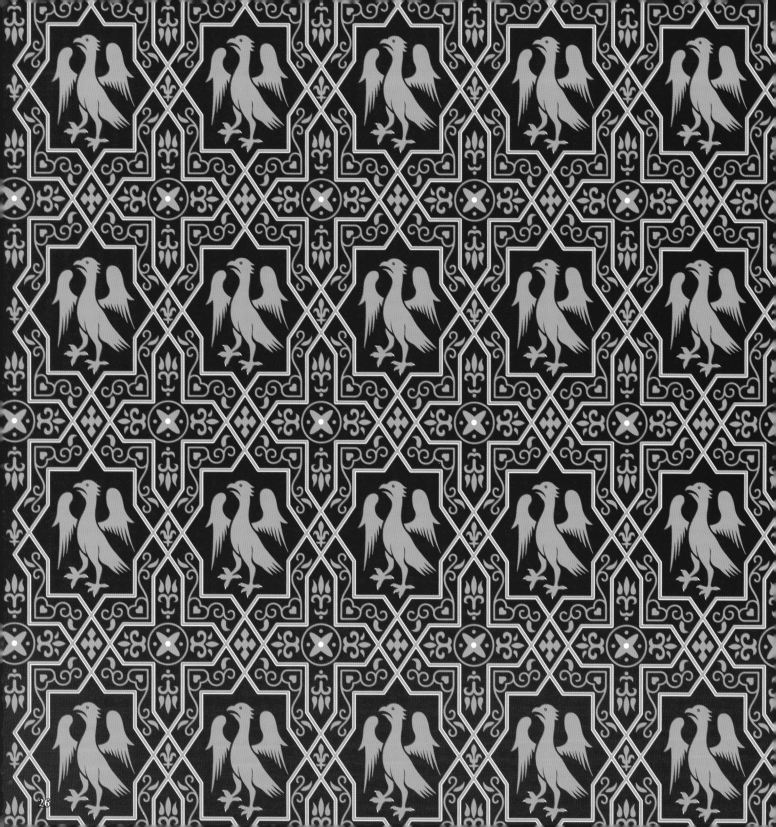

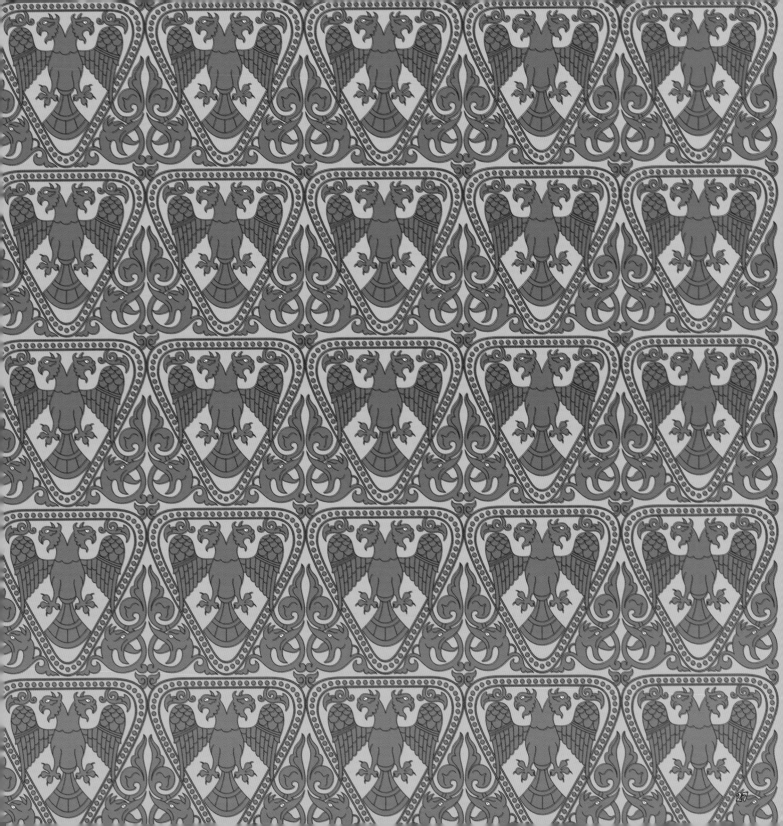

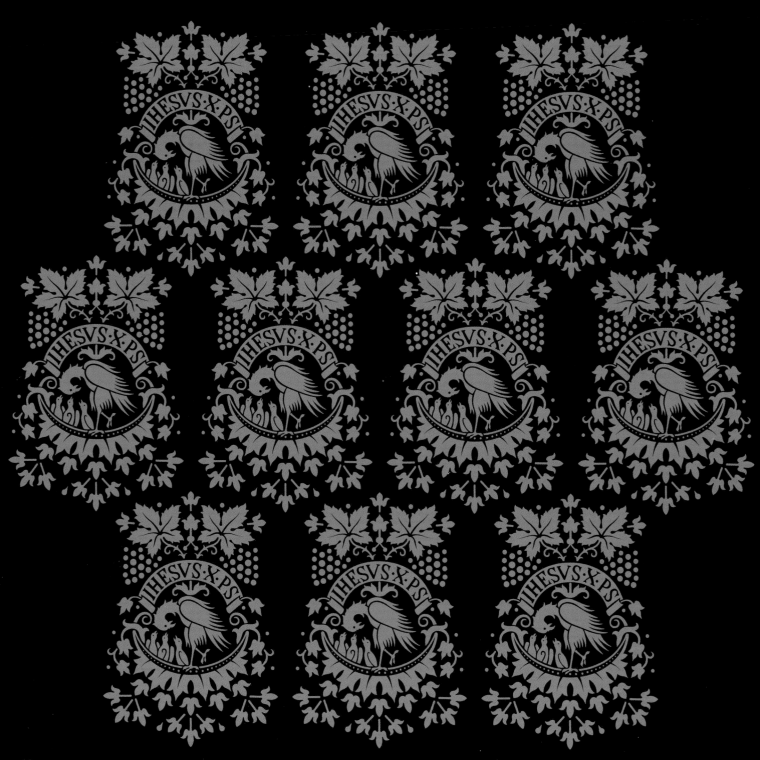

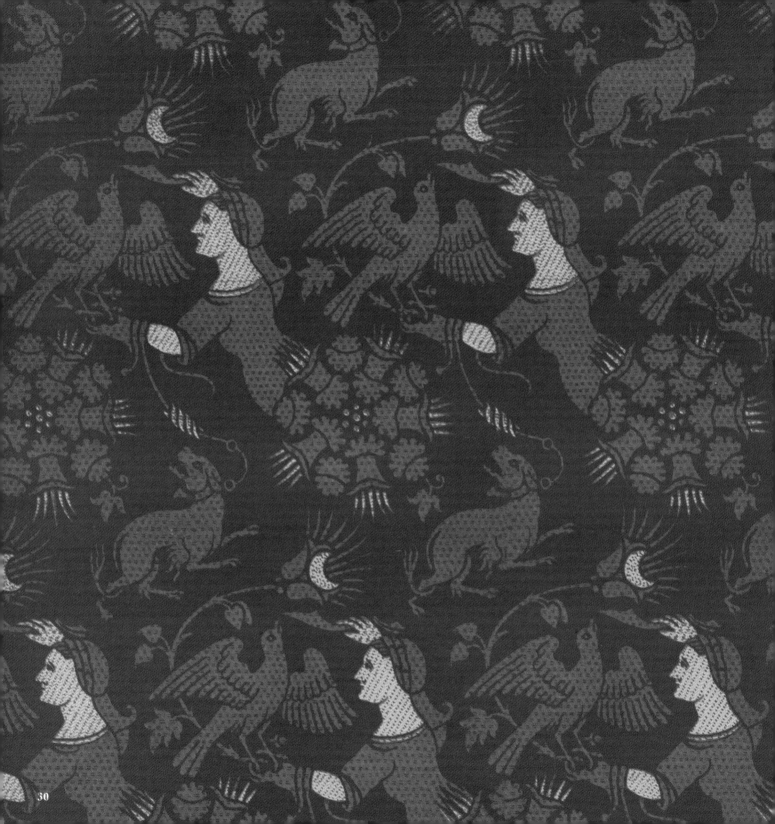

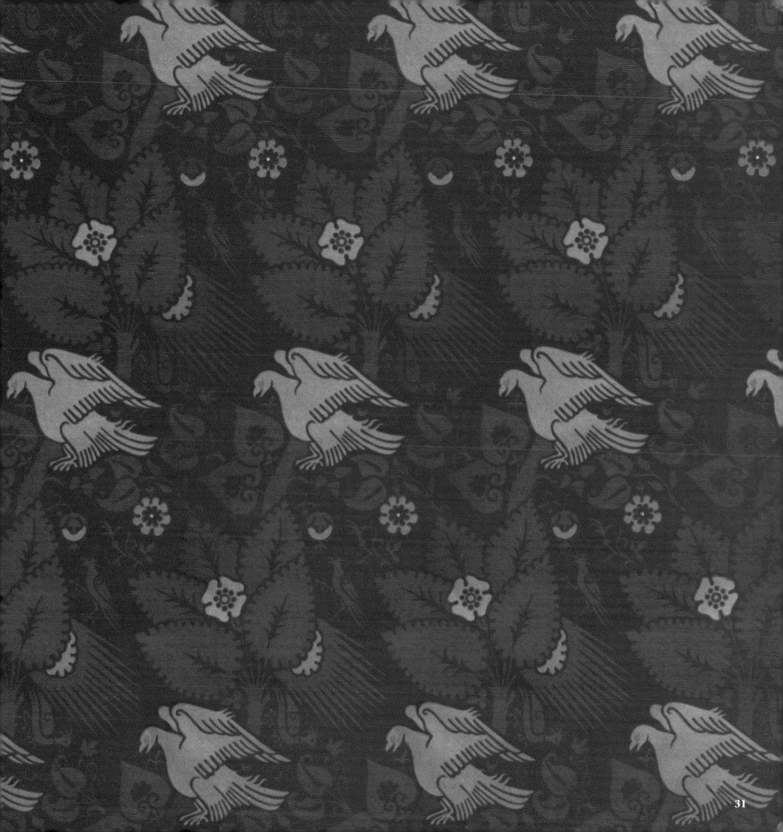

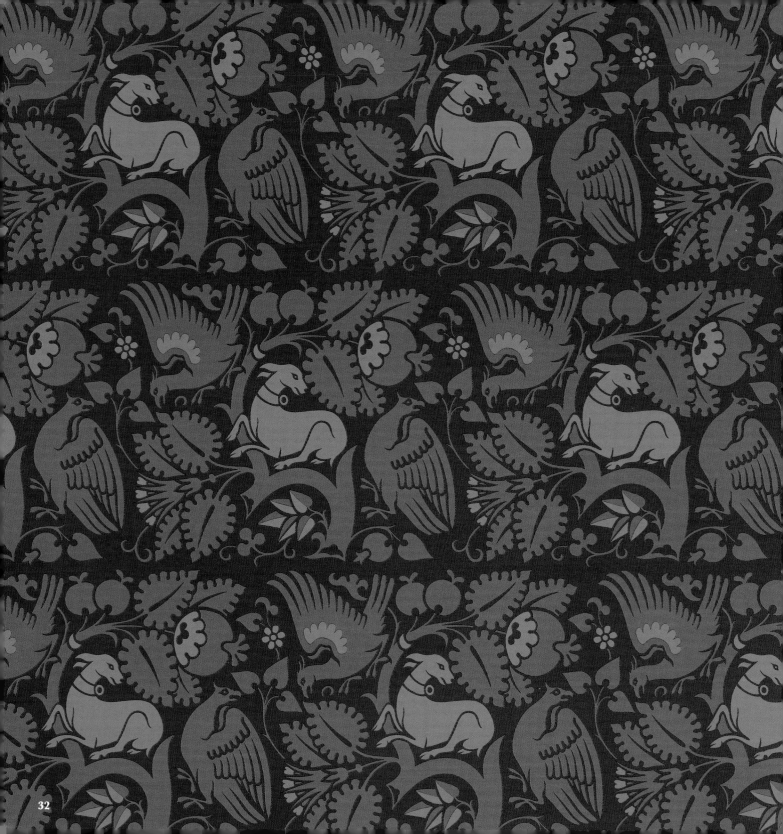

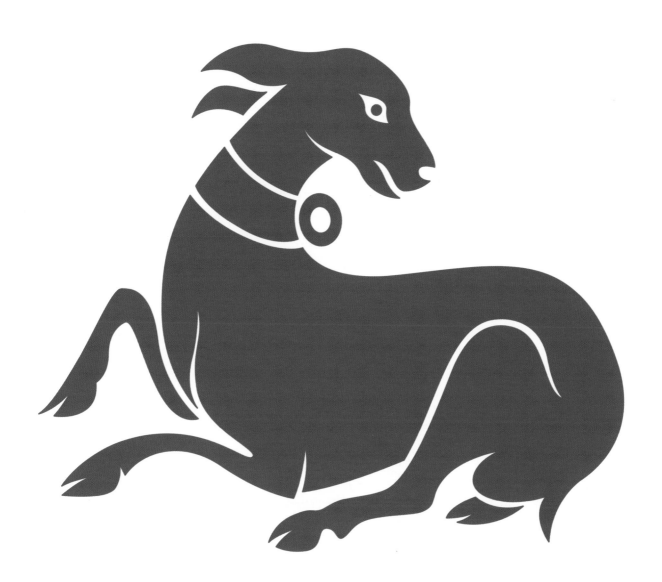

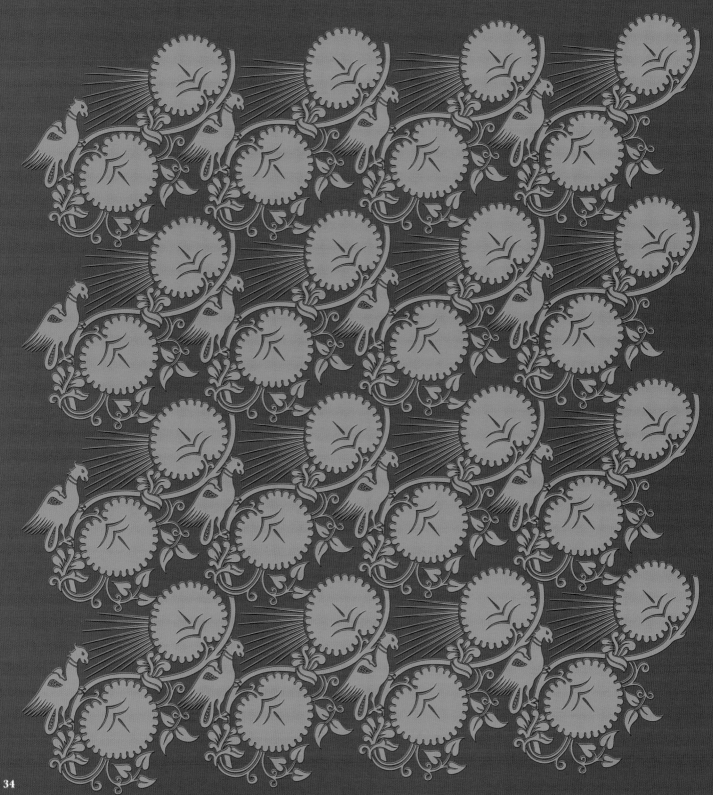

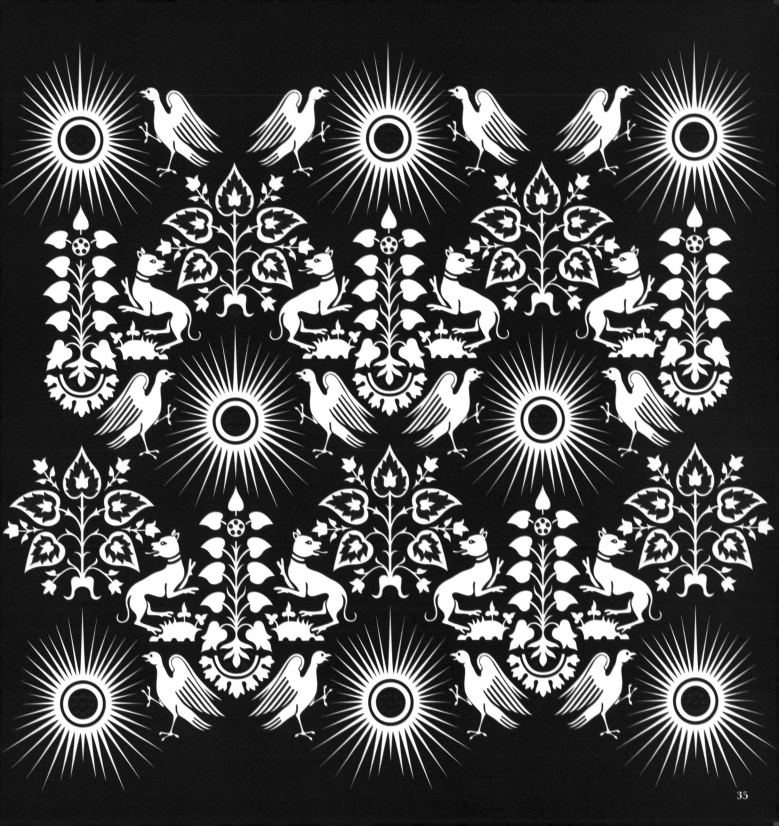

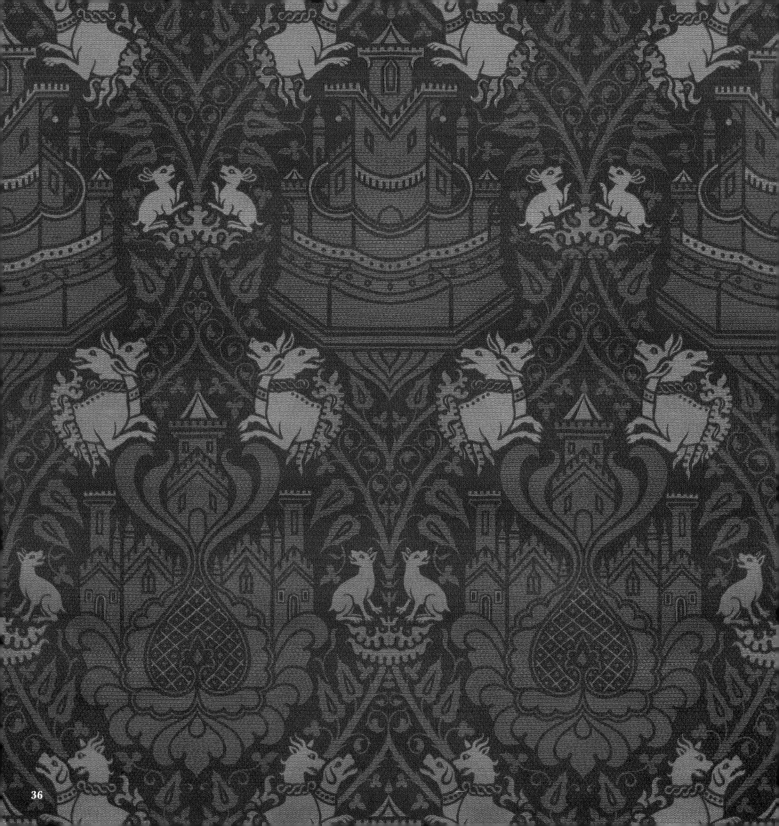

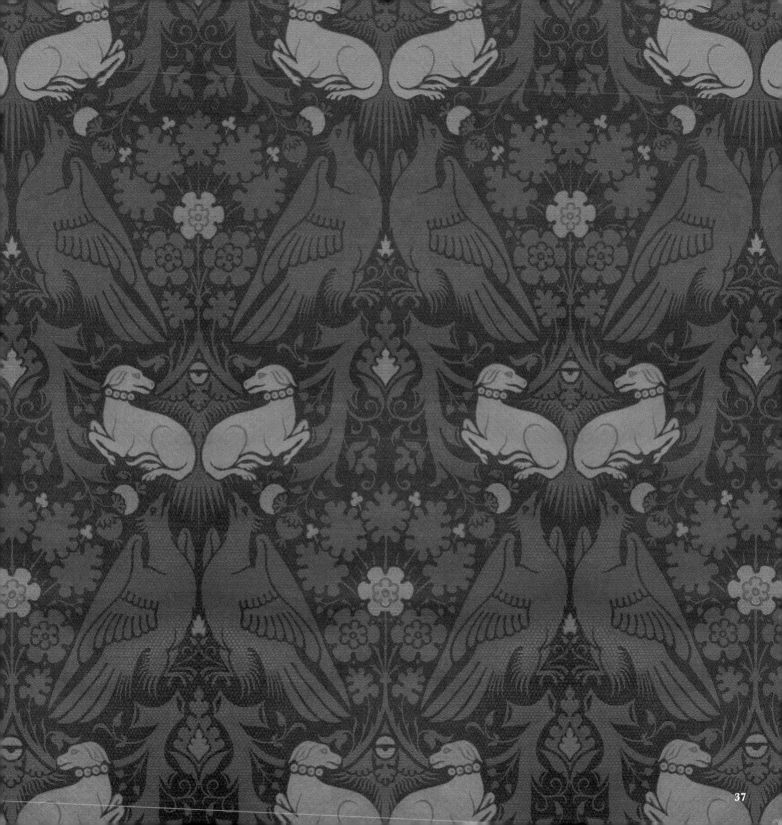

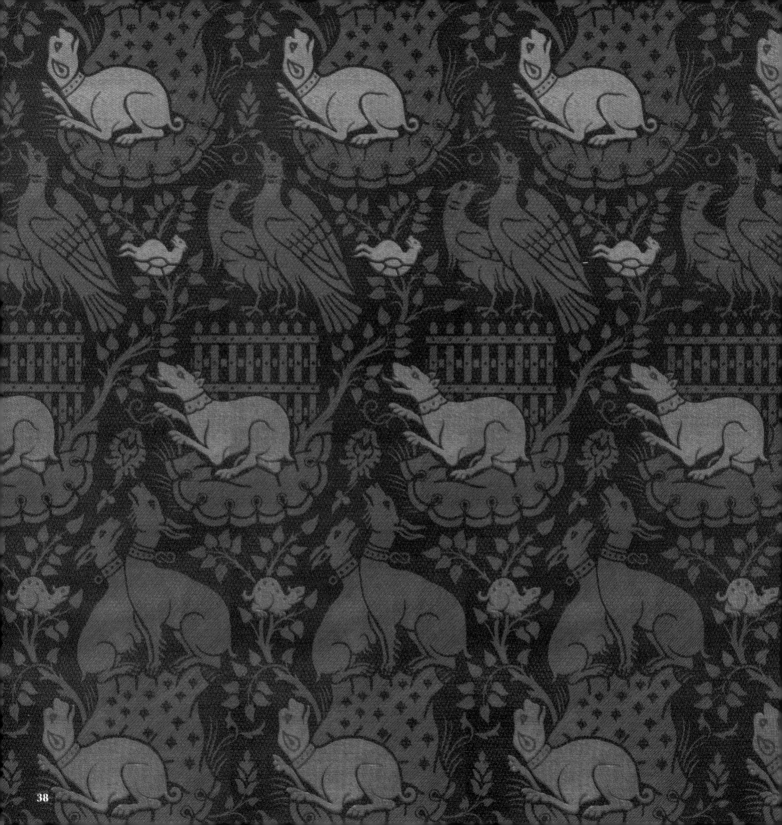

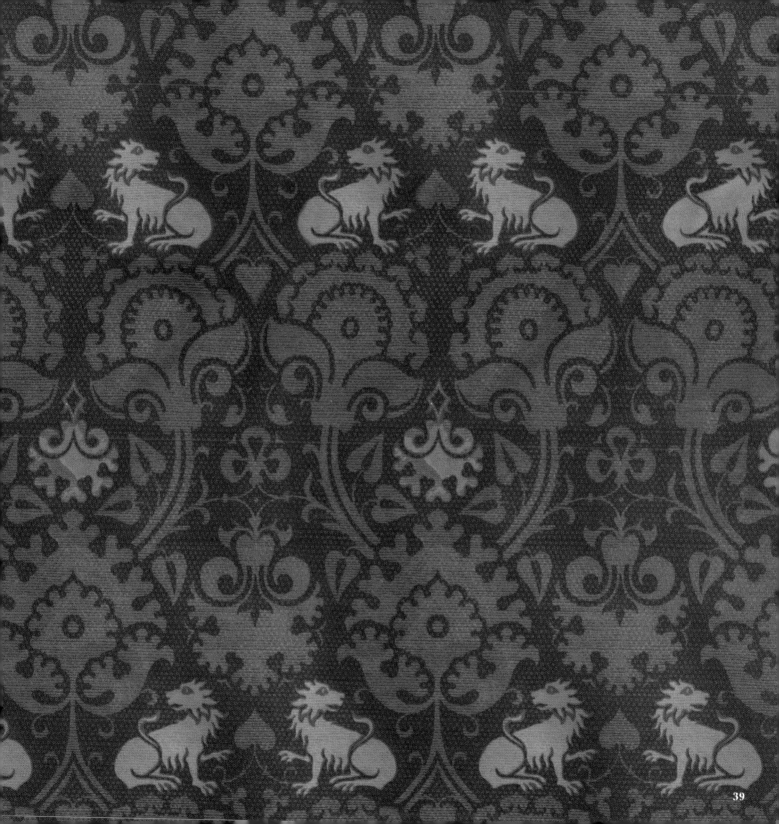

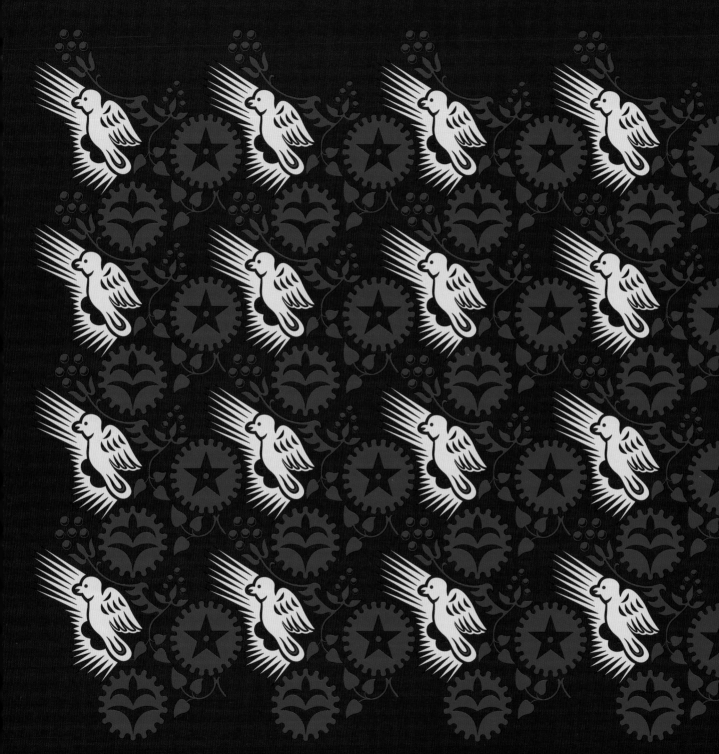

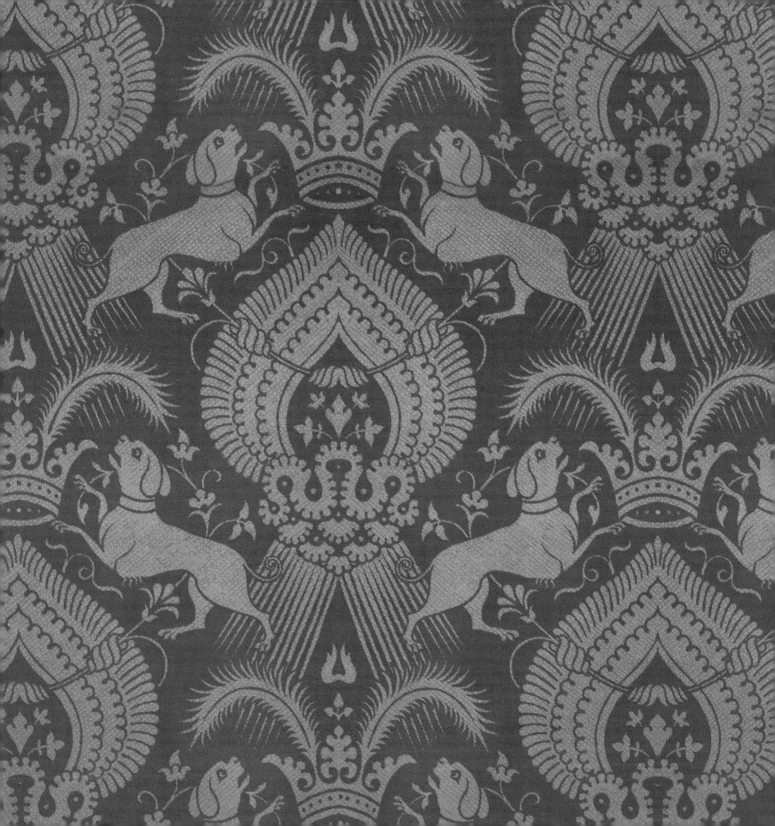

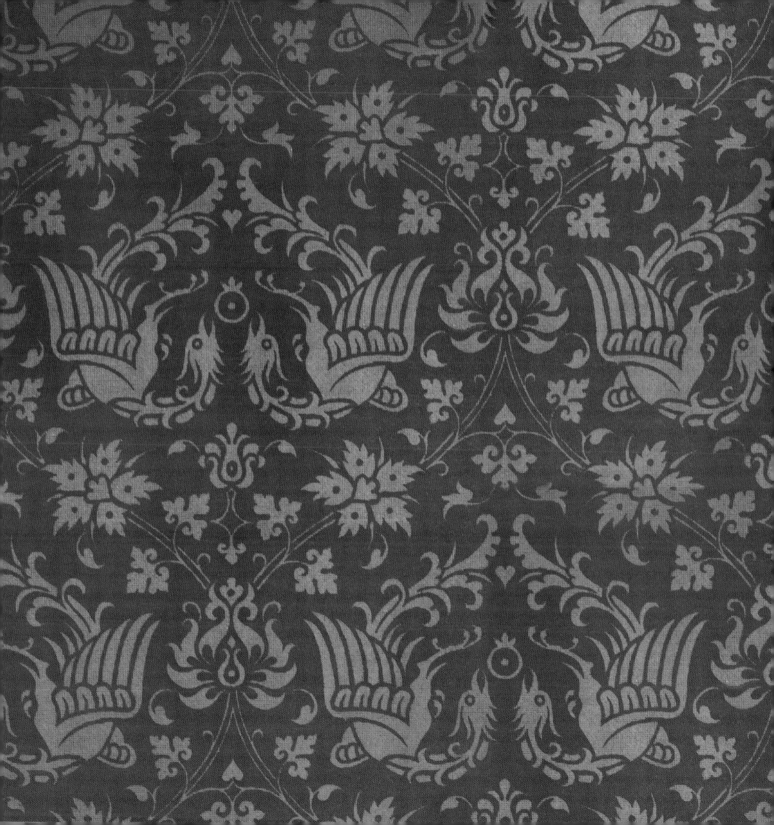

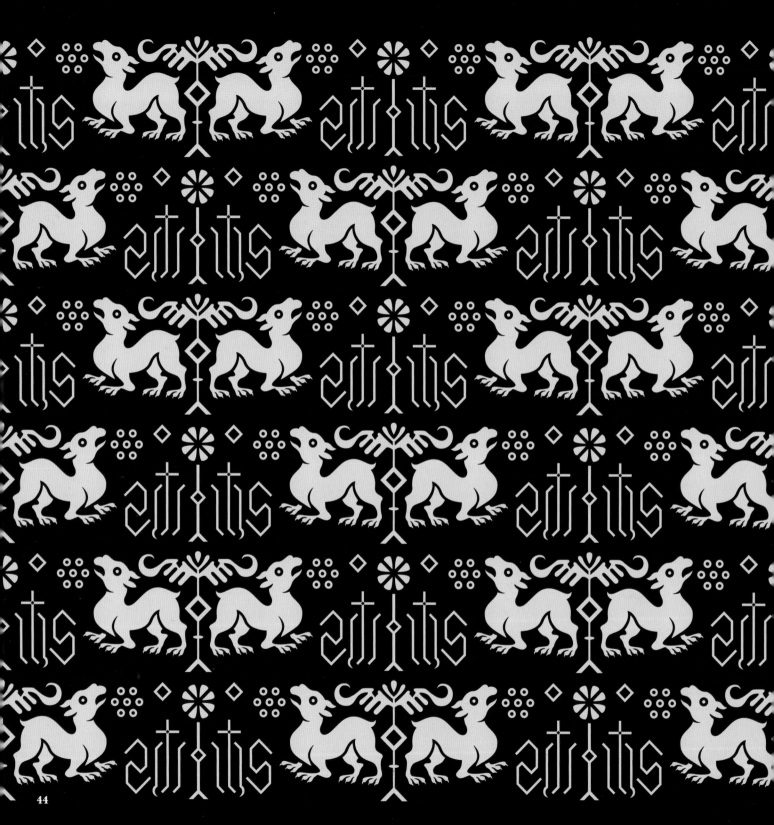

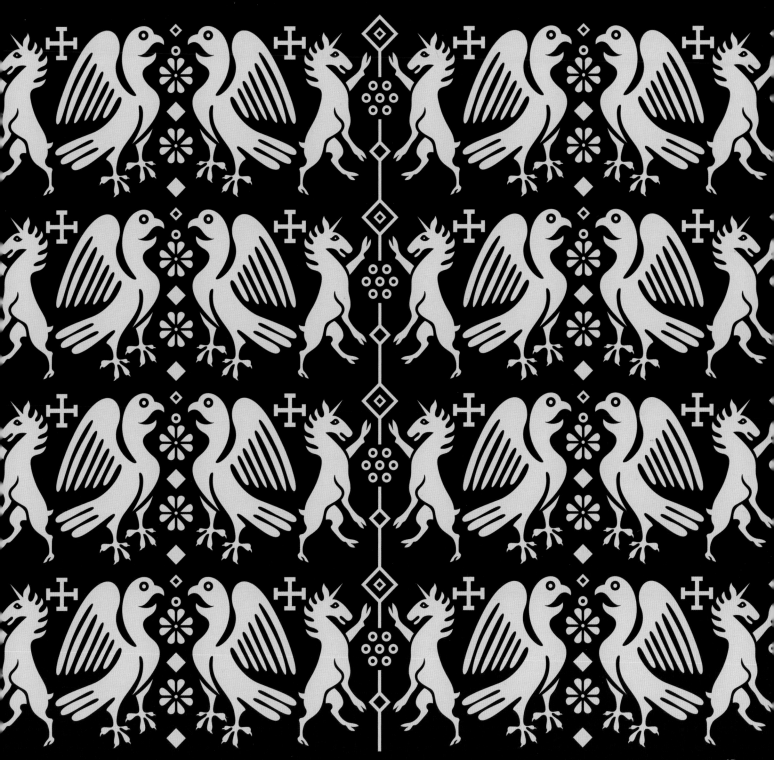

45

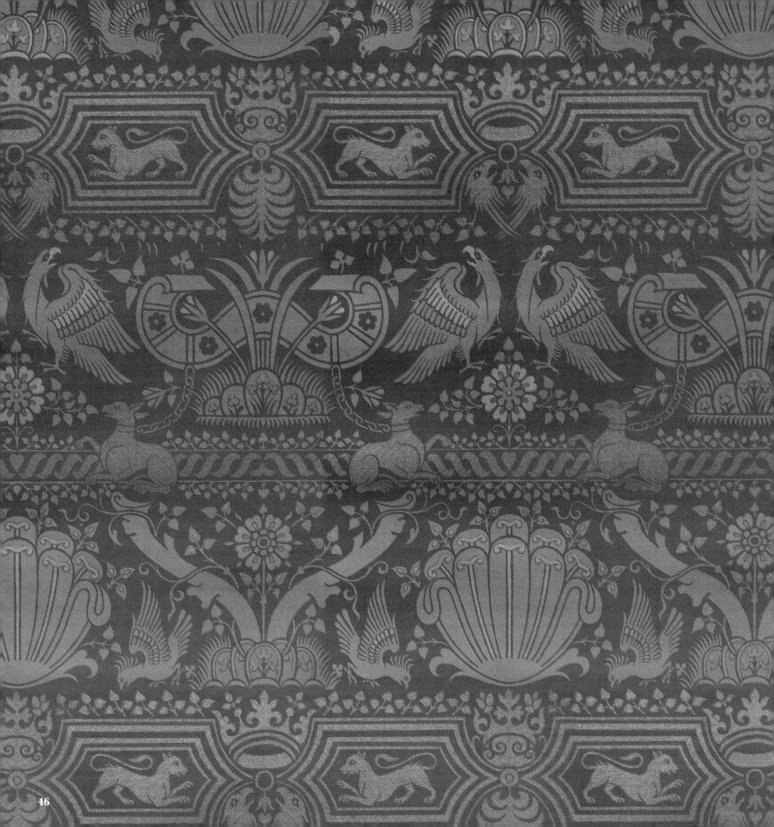

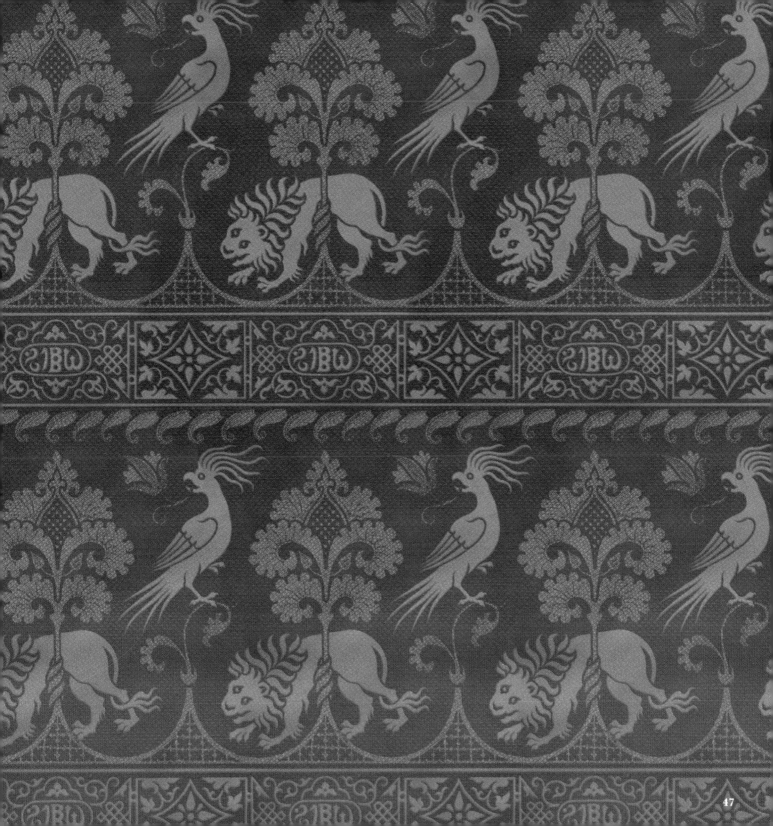

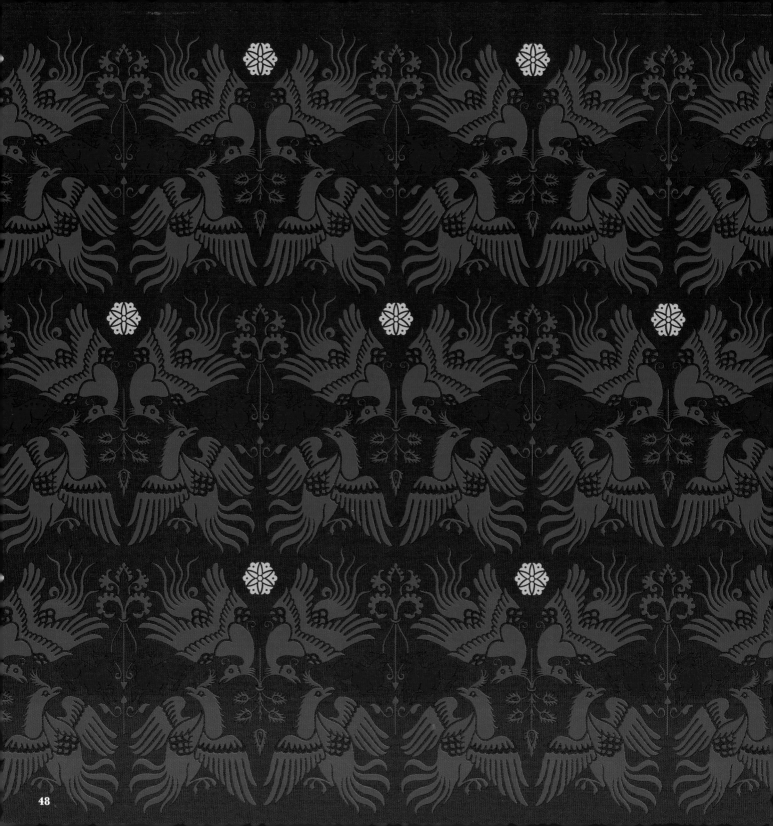

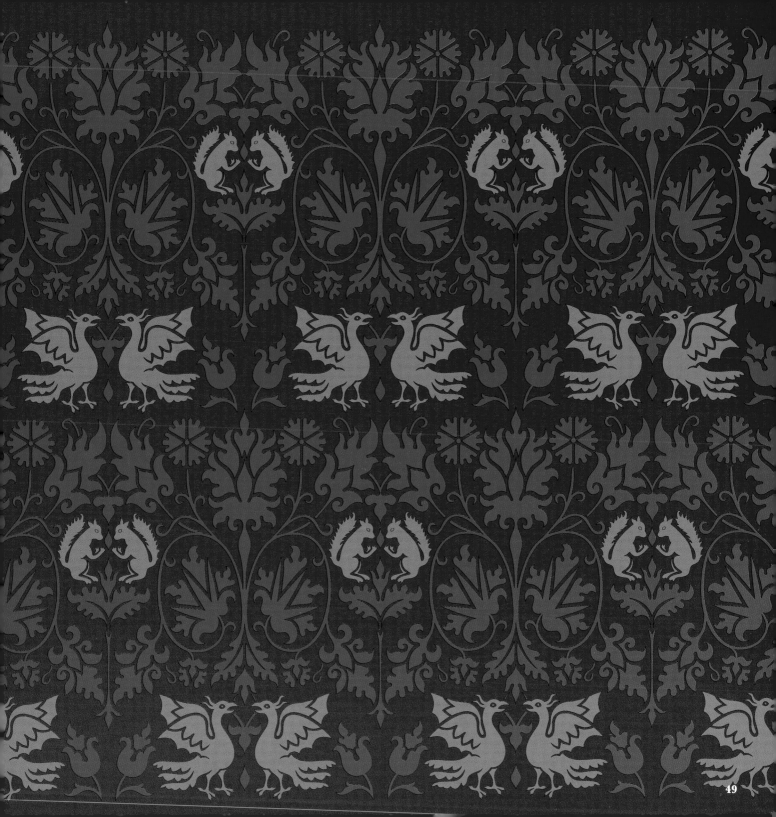

49

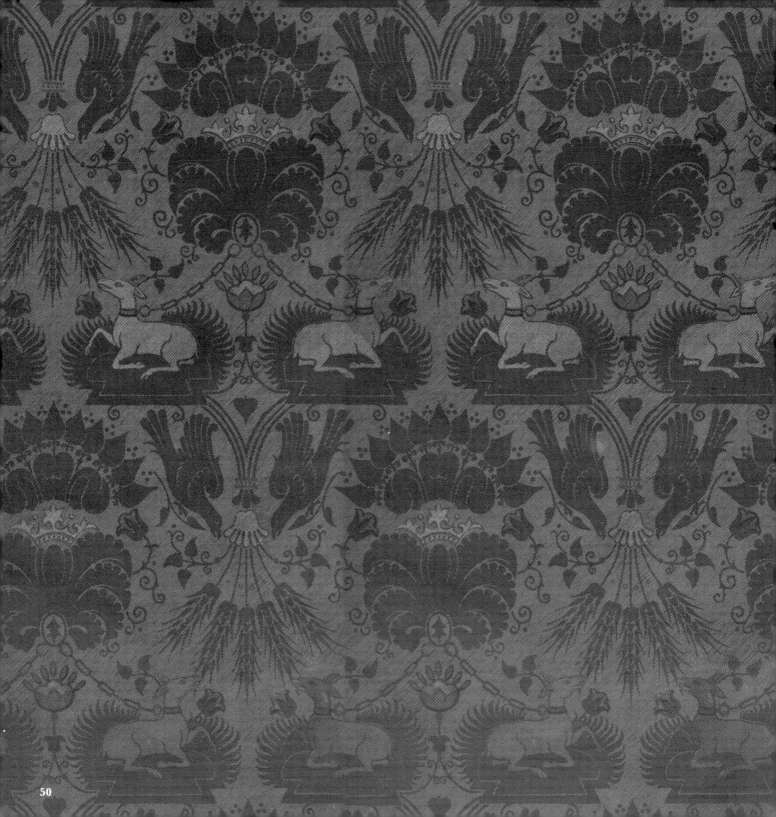

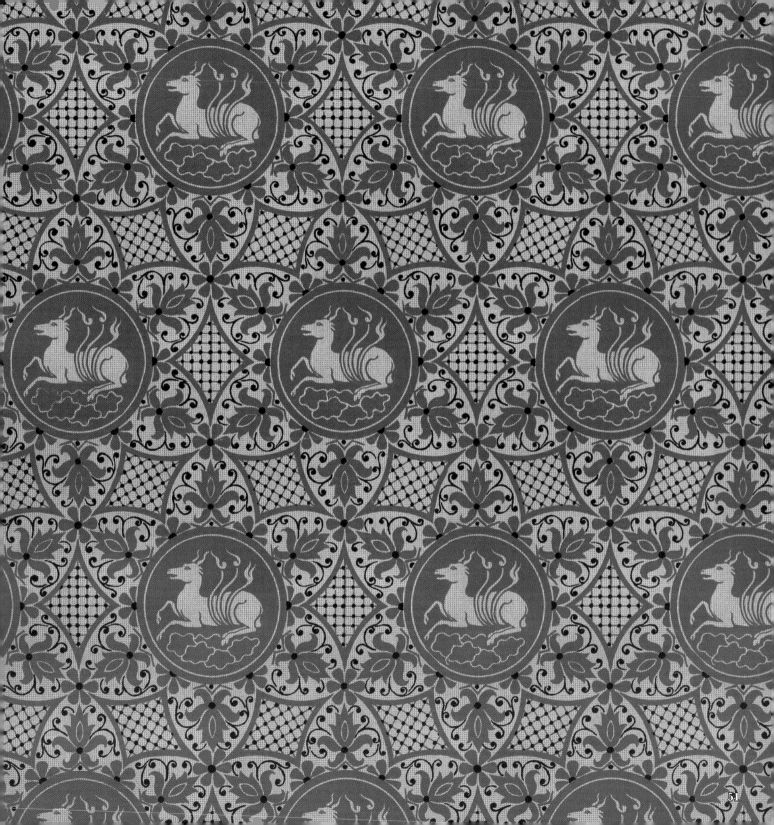

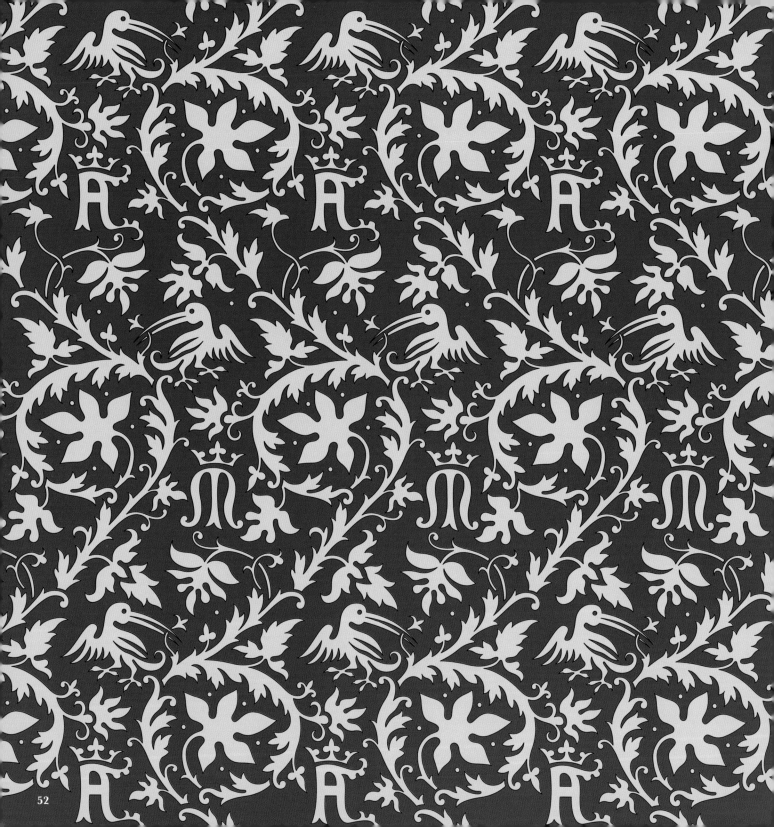

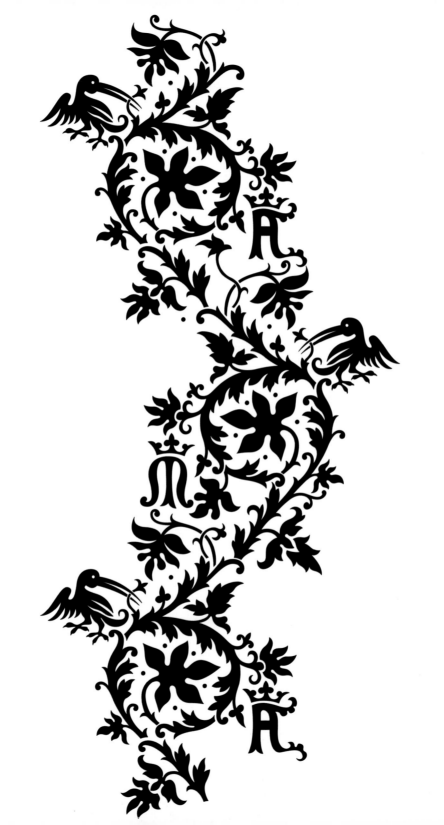

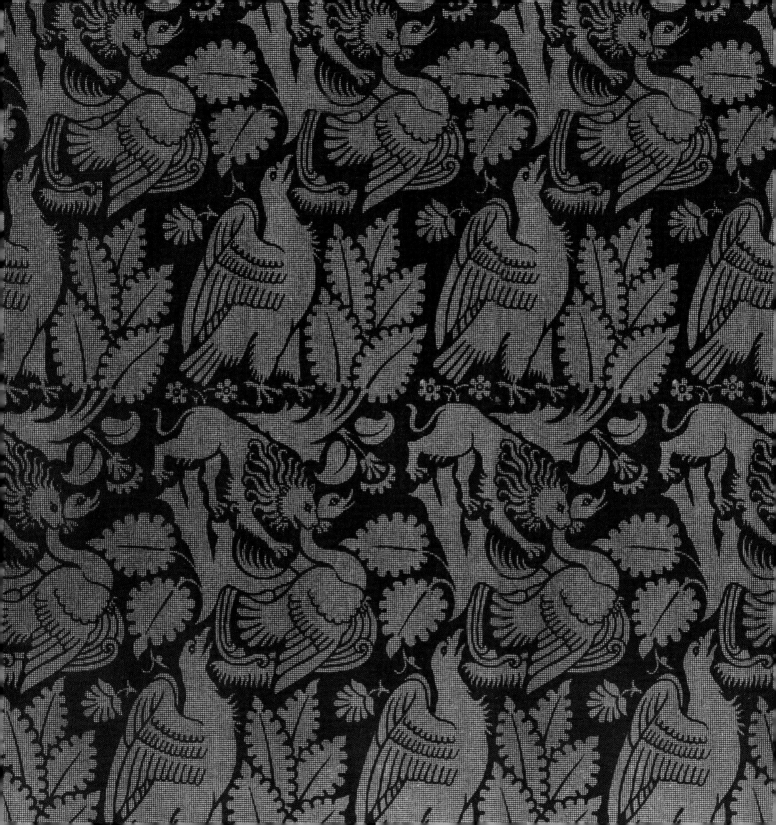

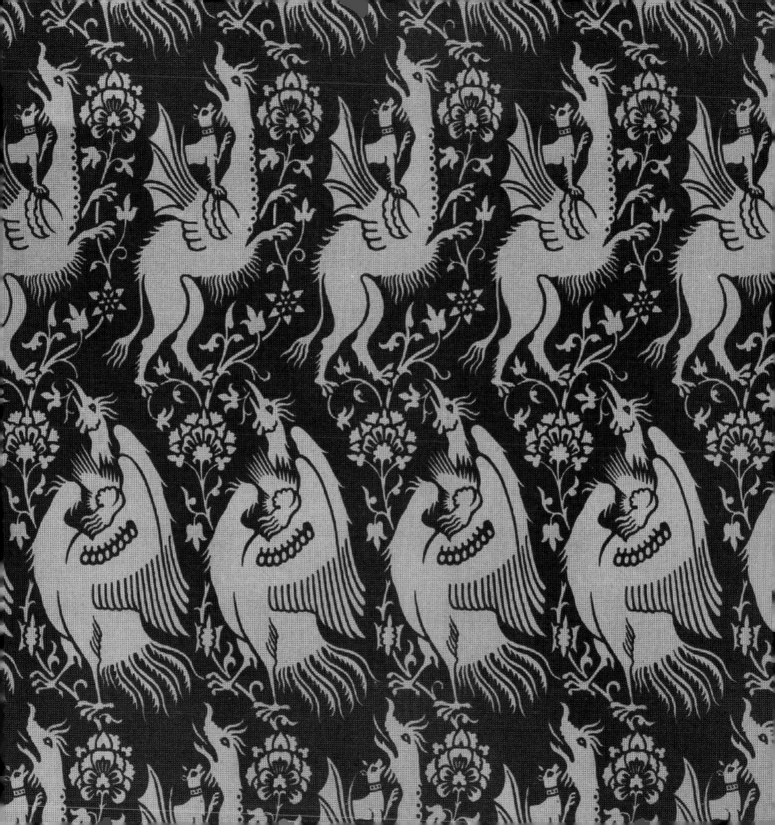

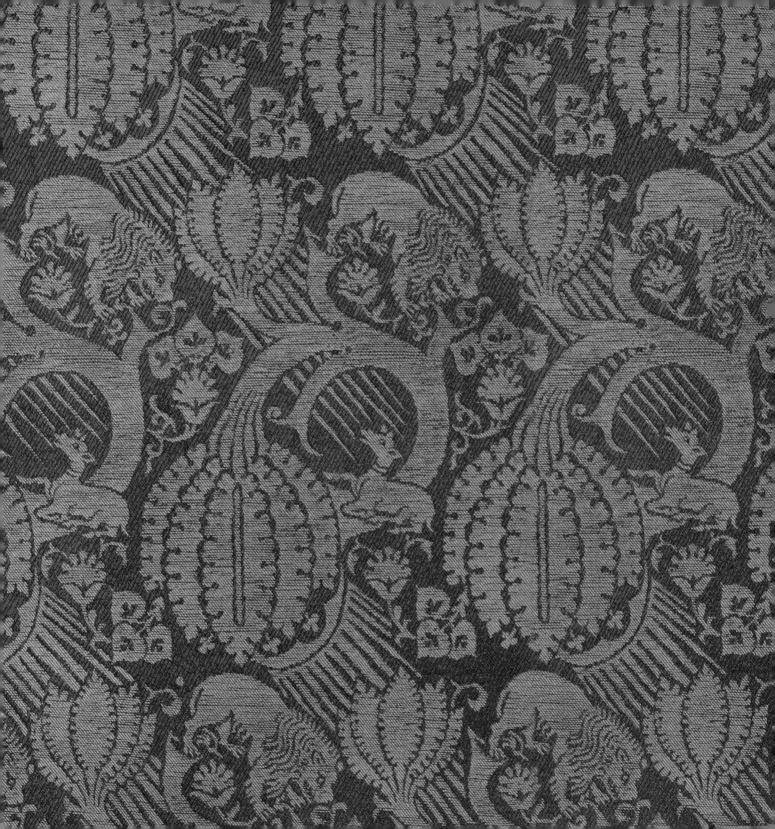

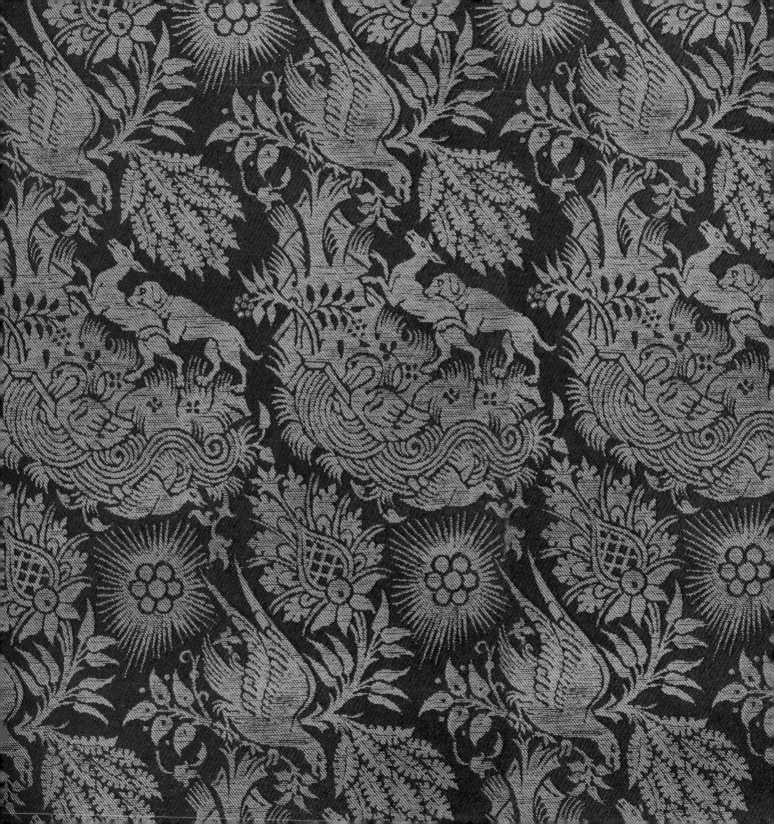

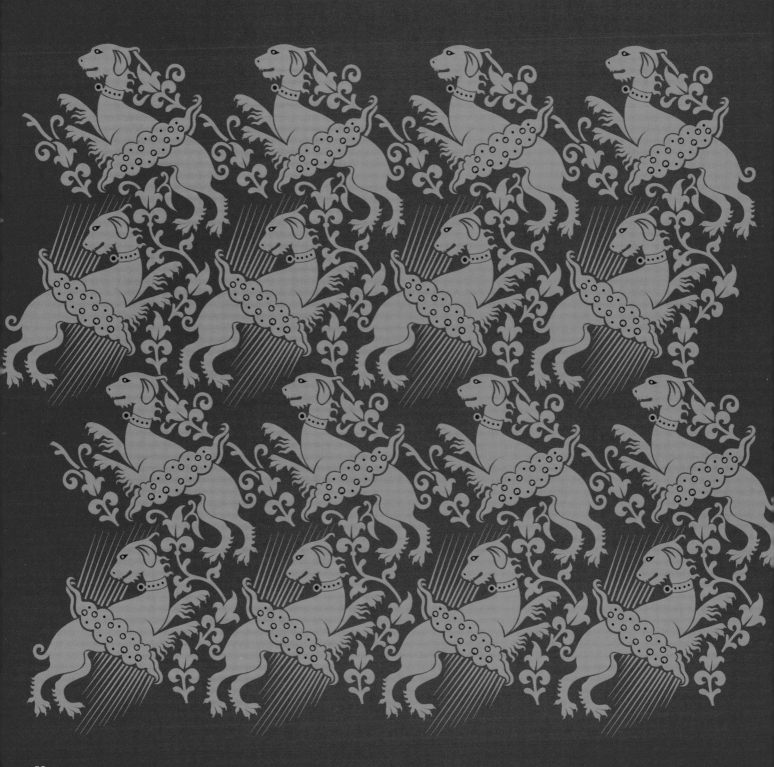

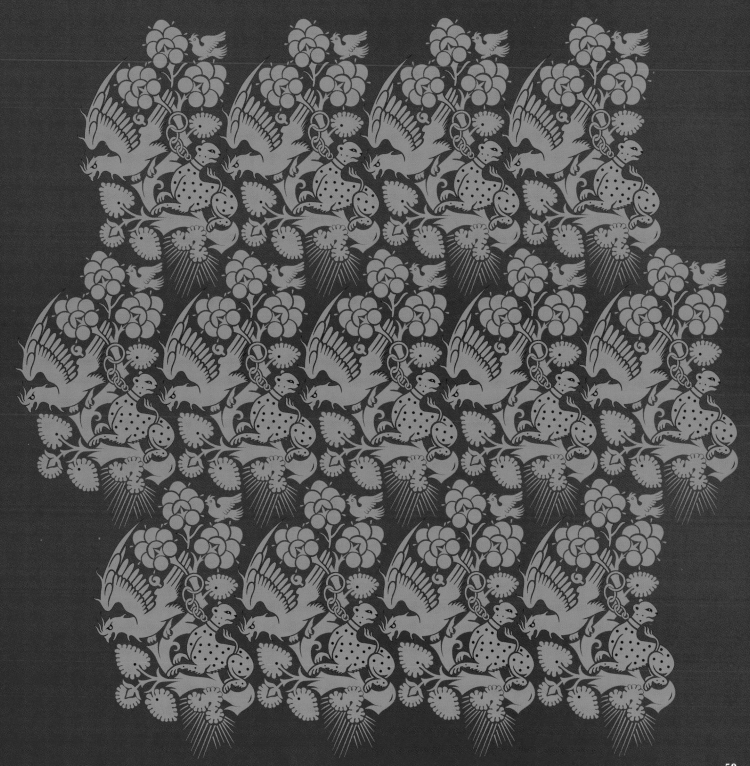

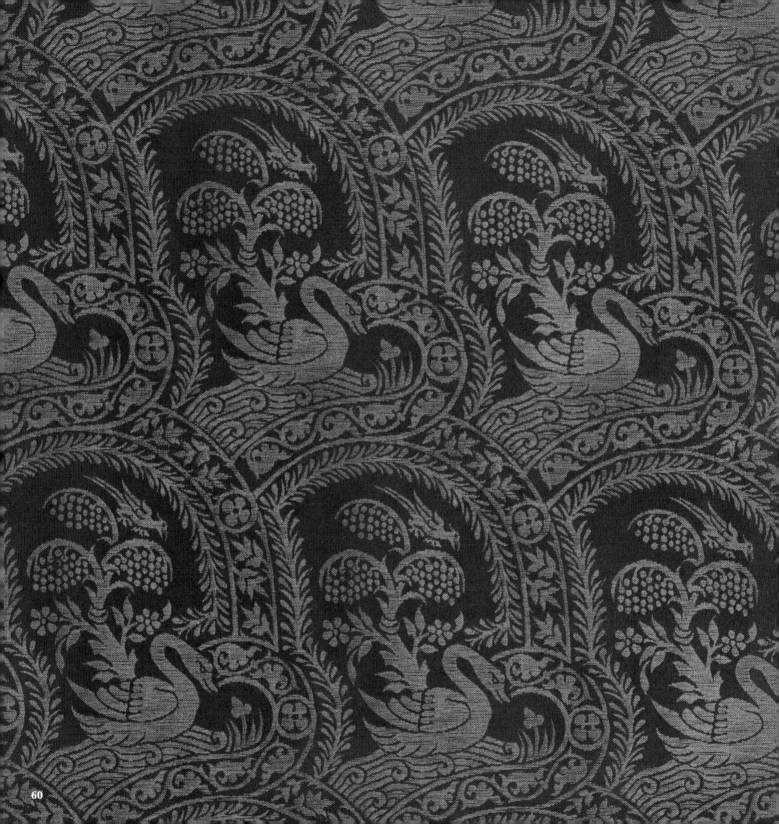

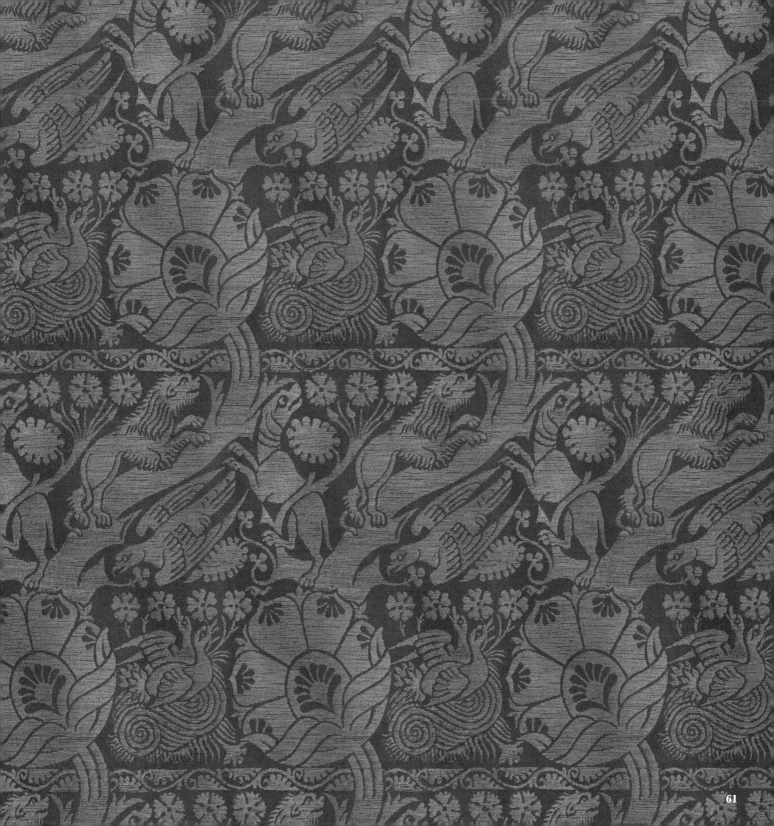

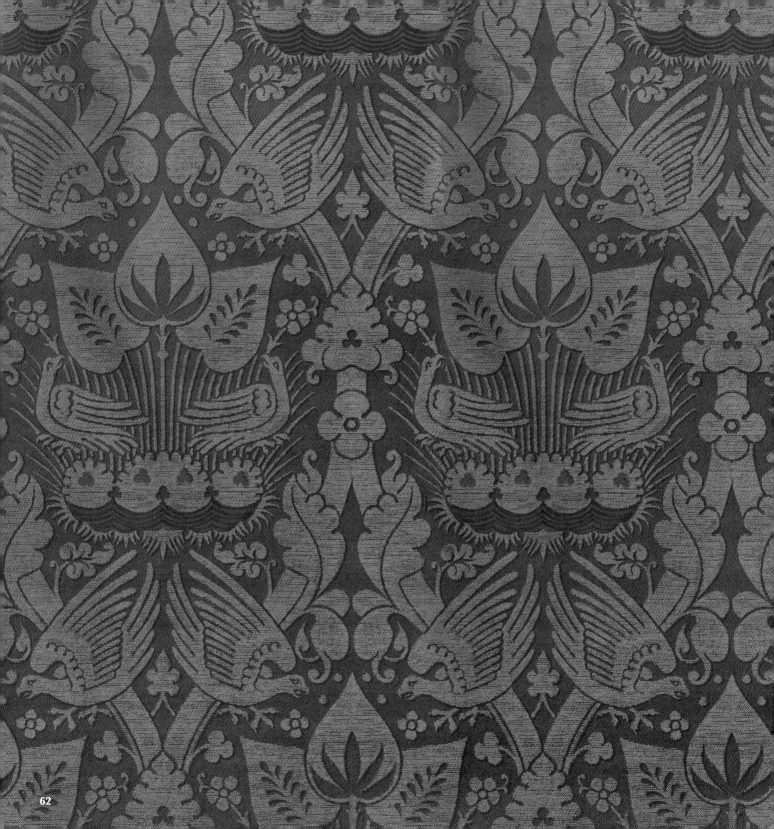

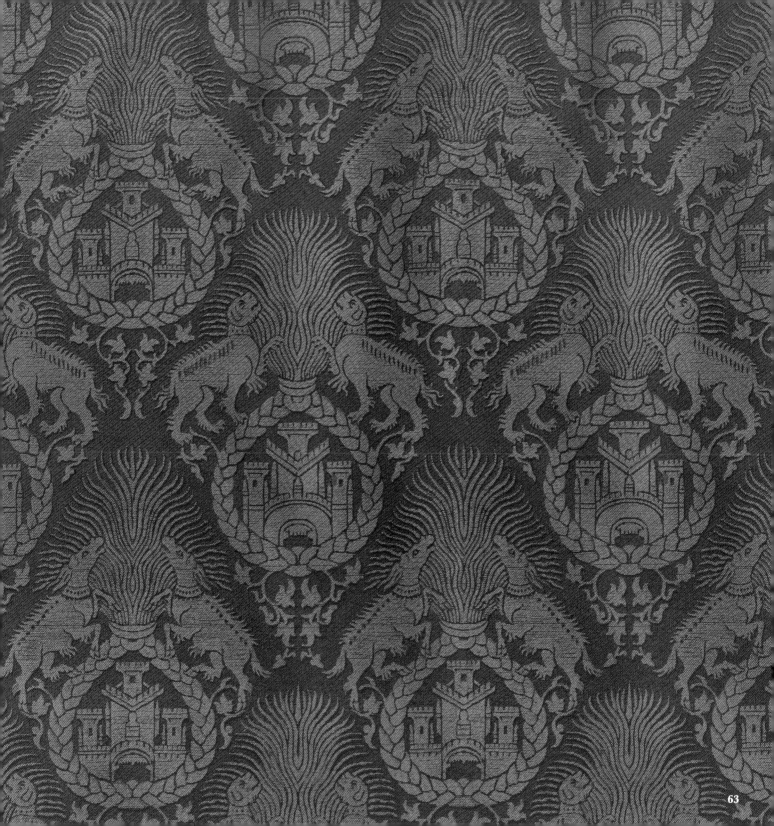

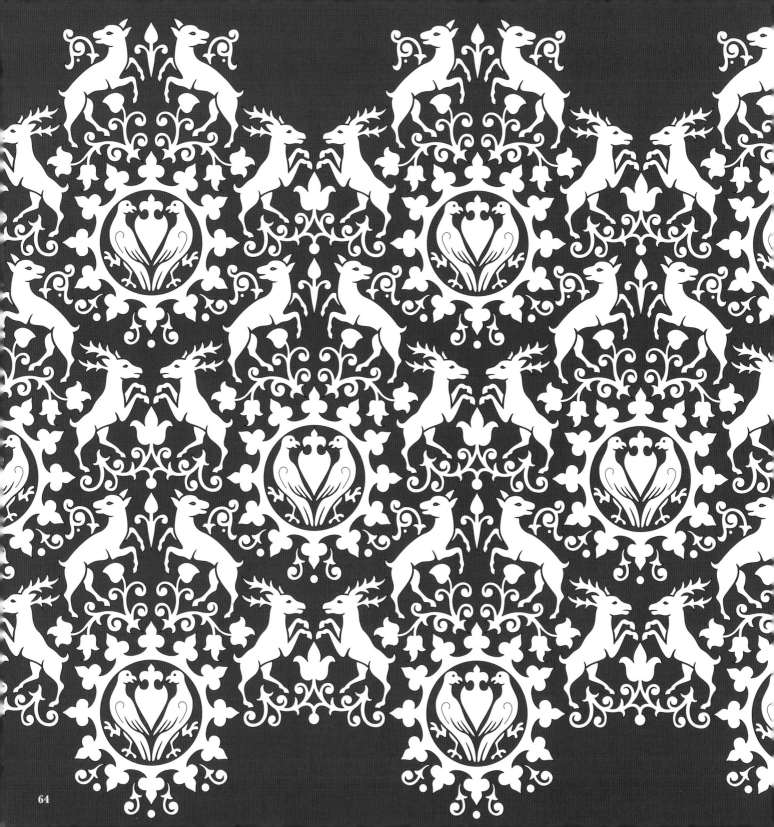

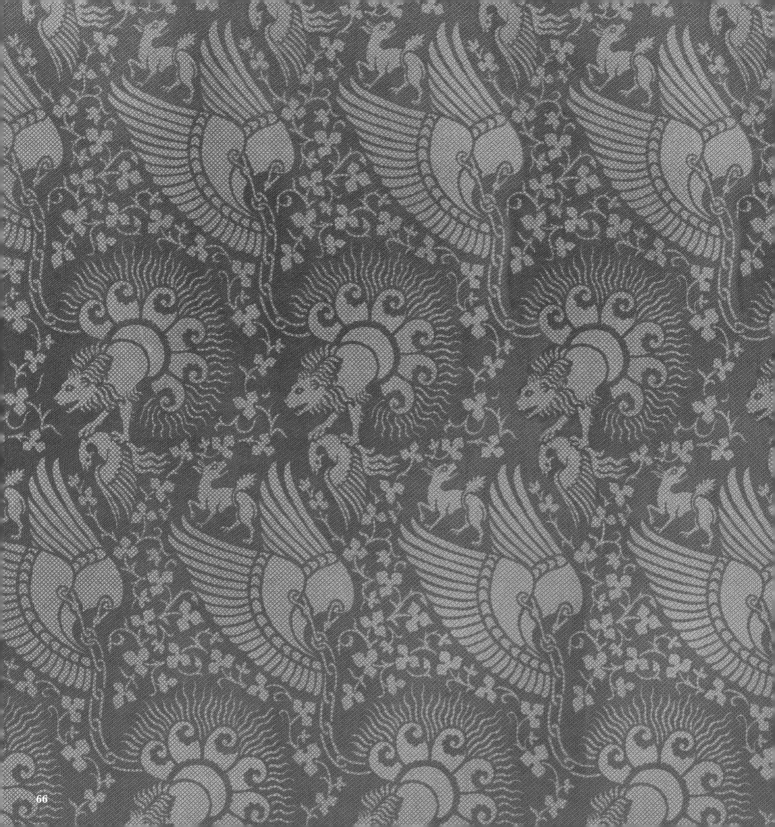

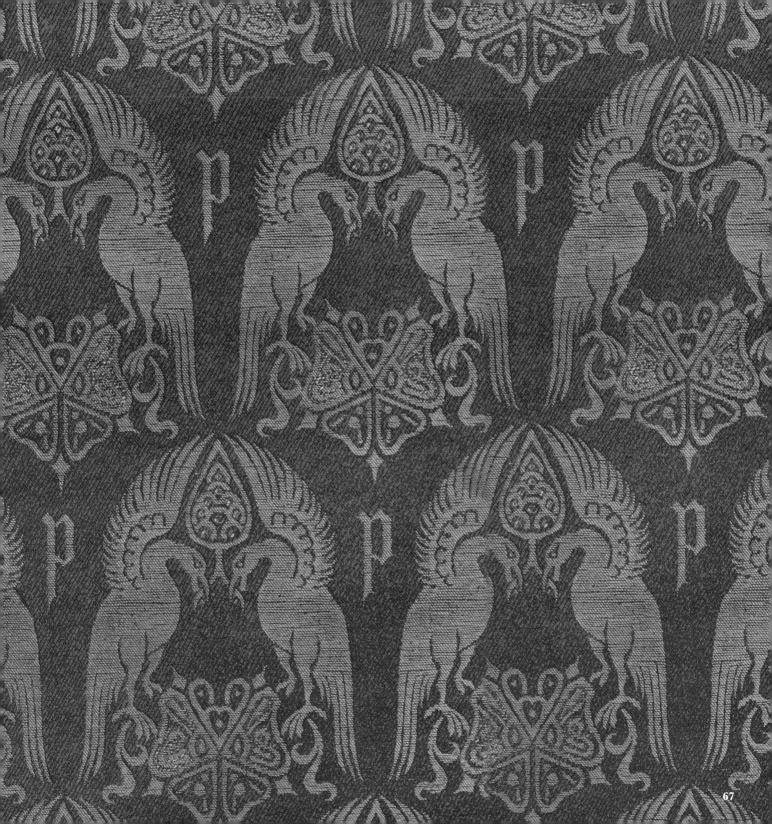

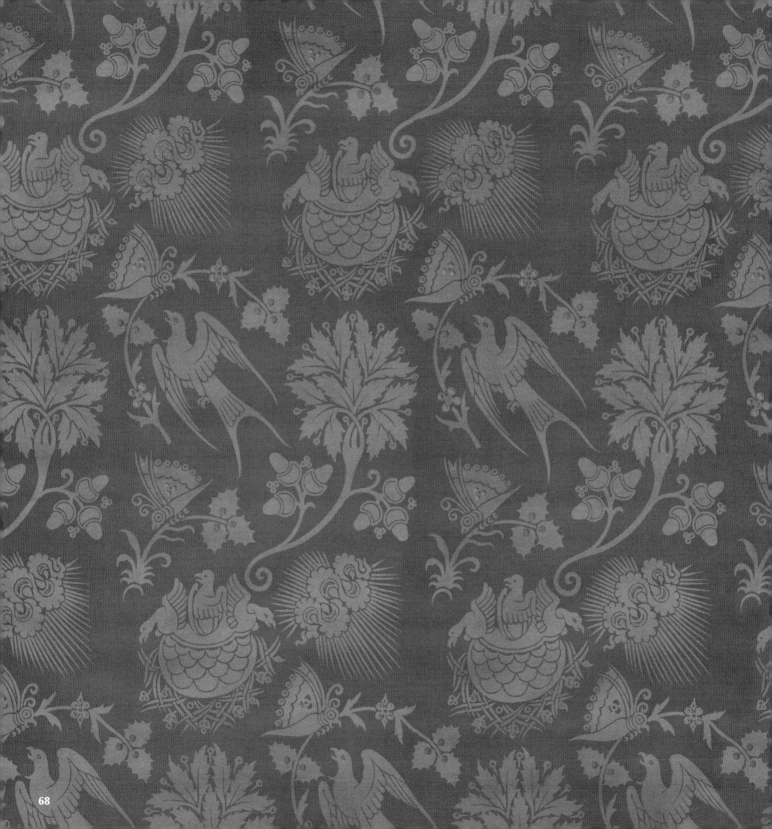

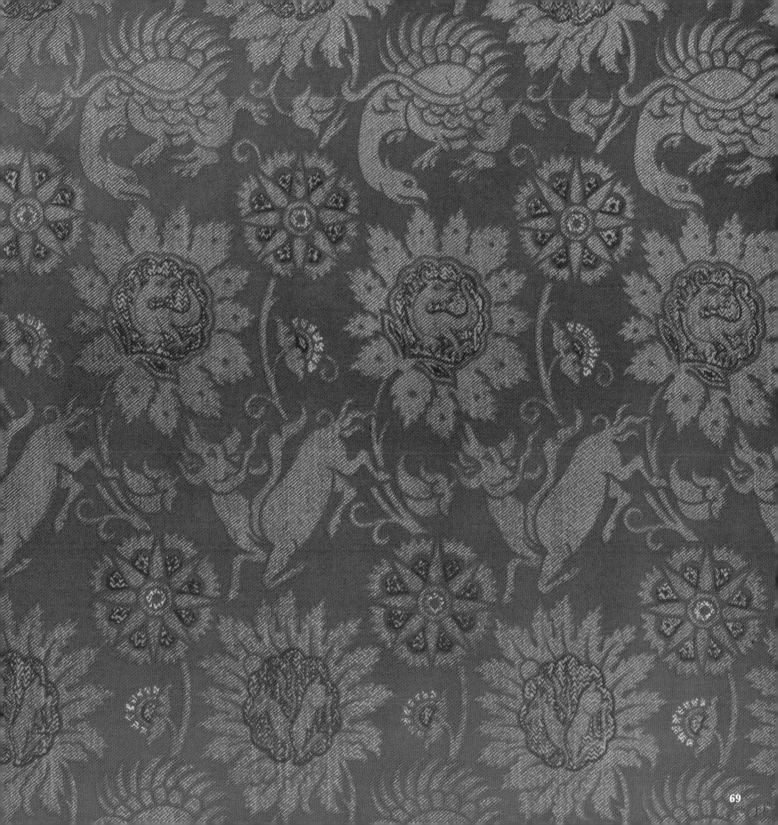

69

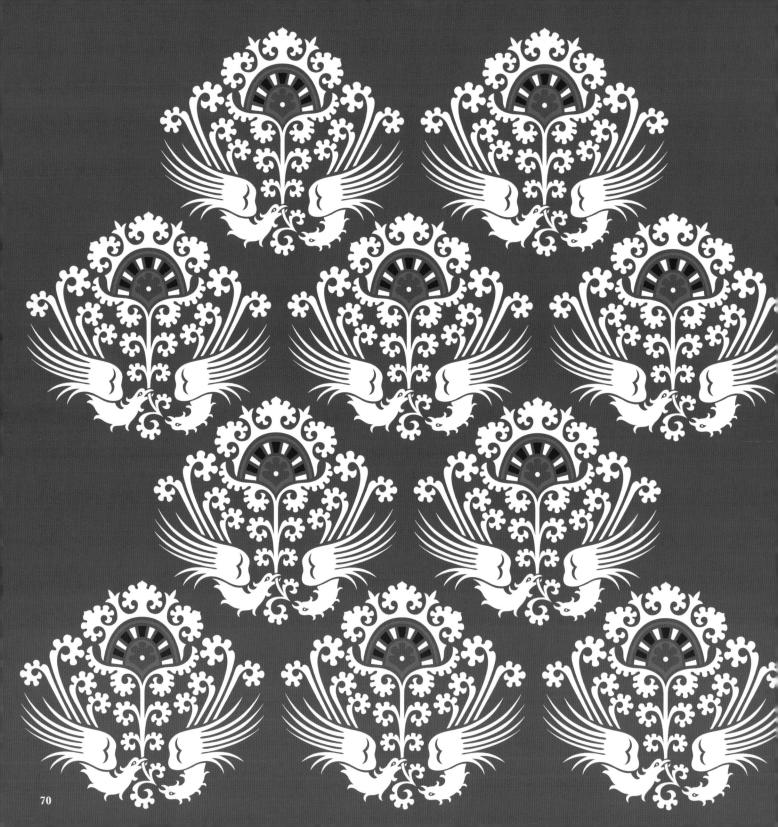

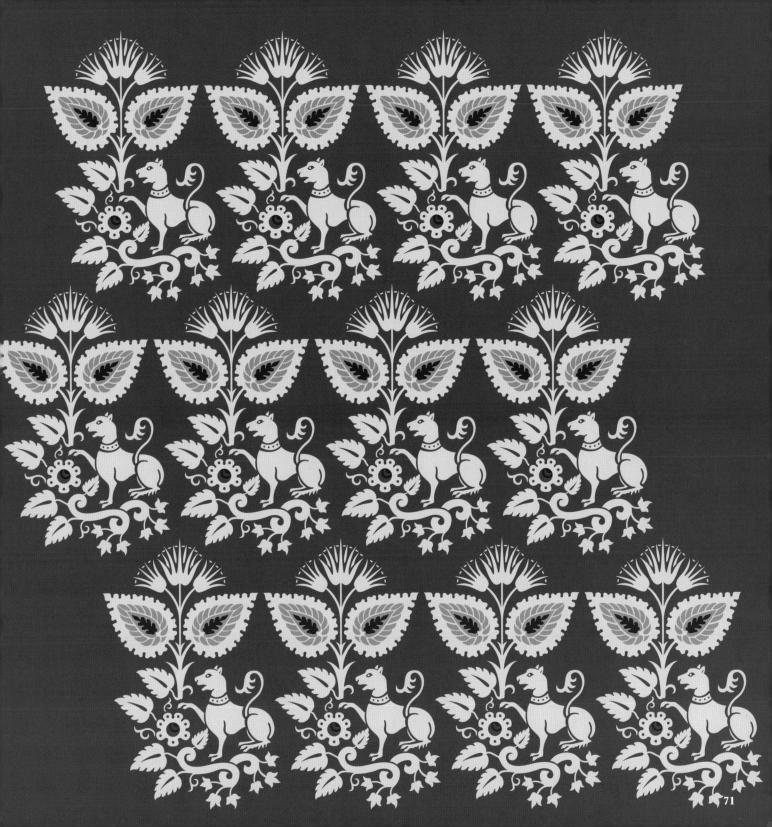

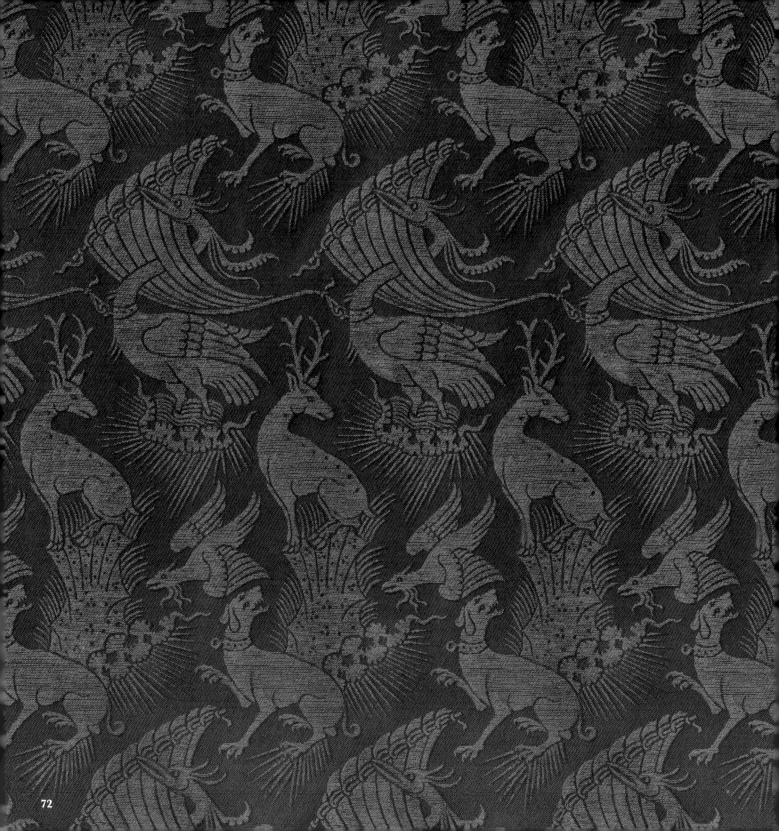

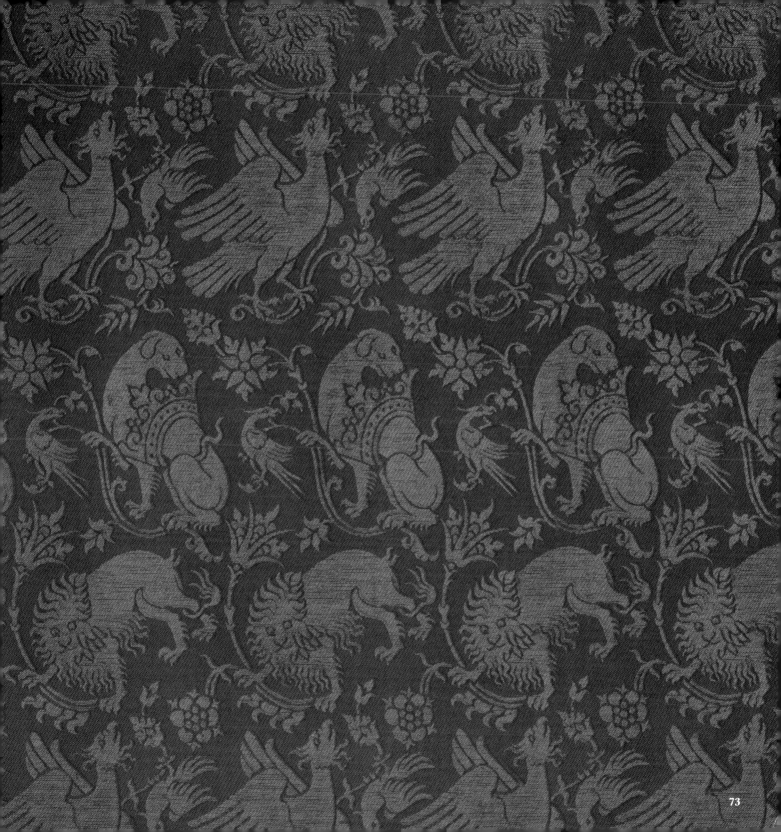

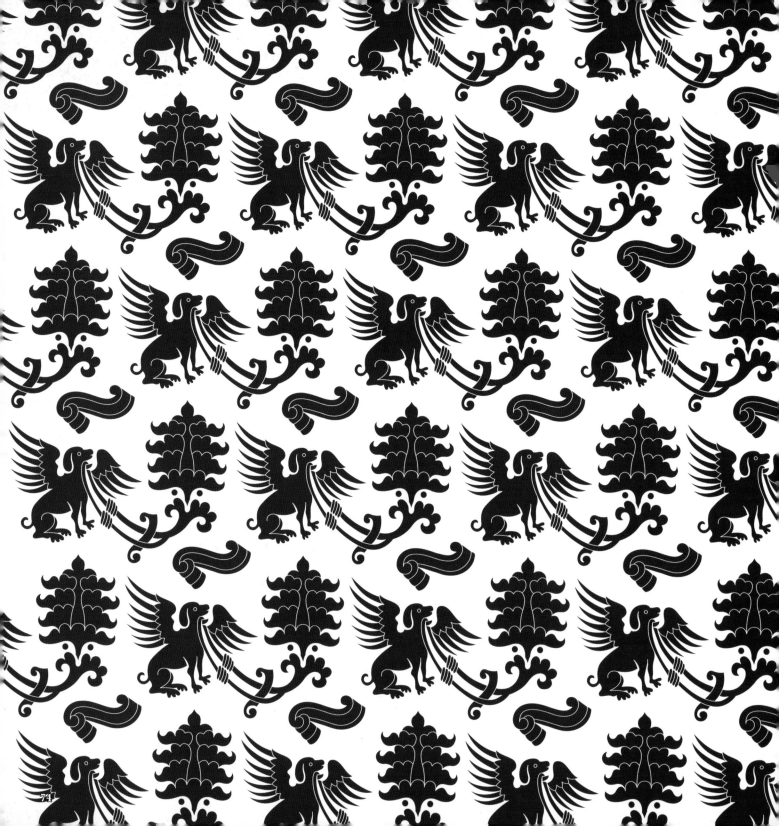

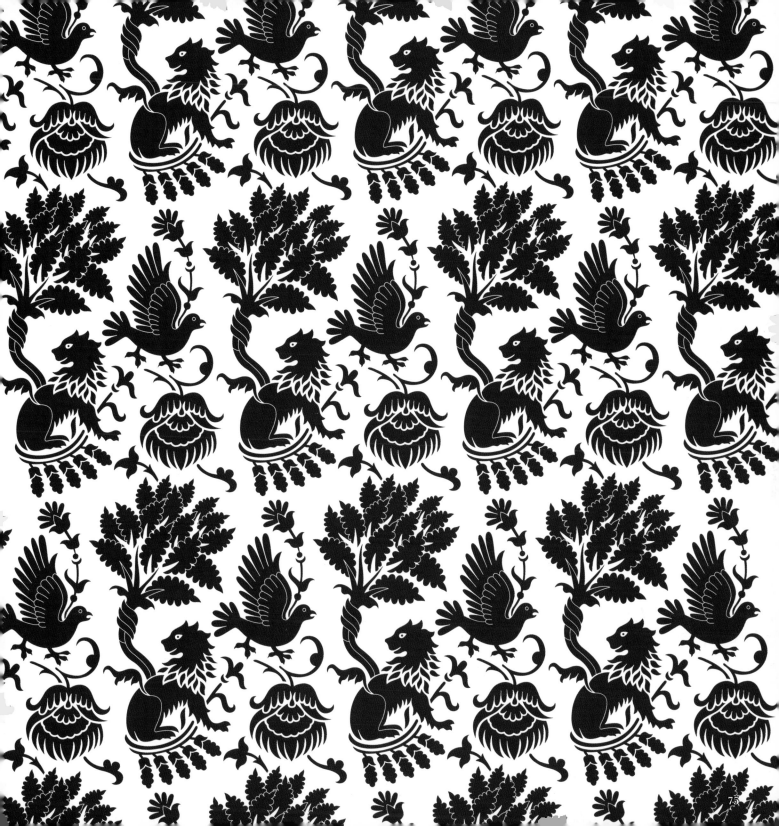

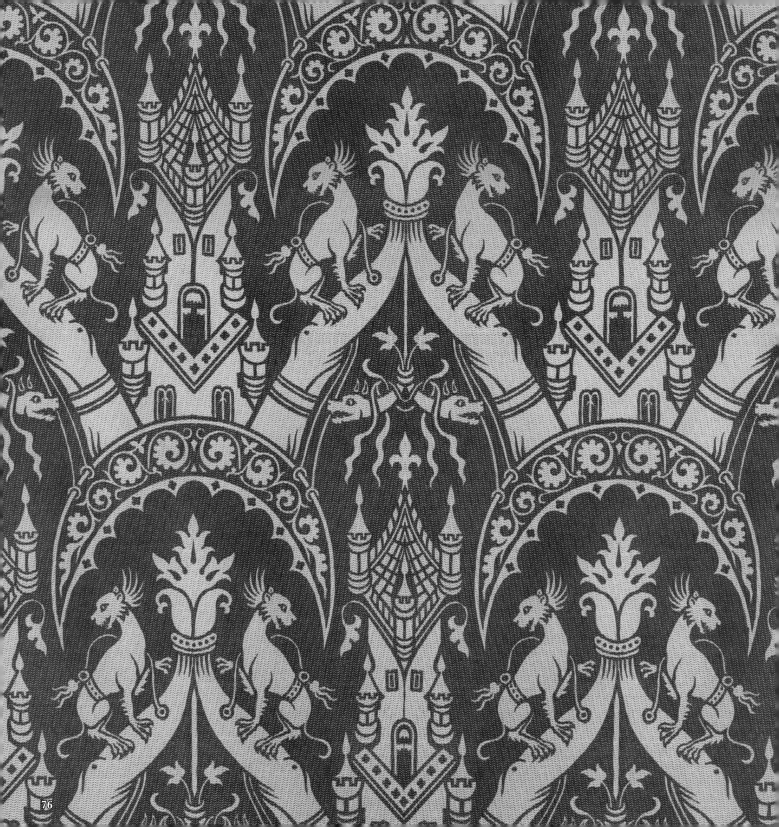

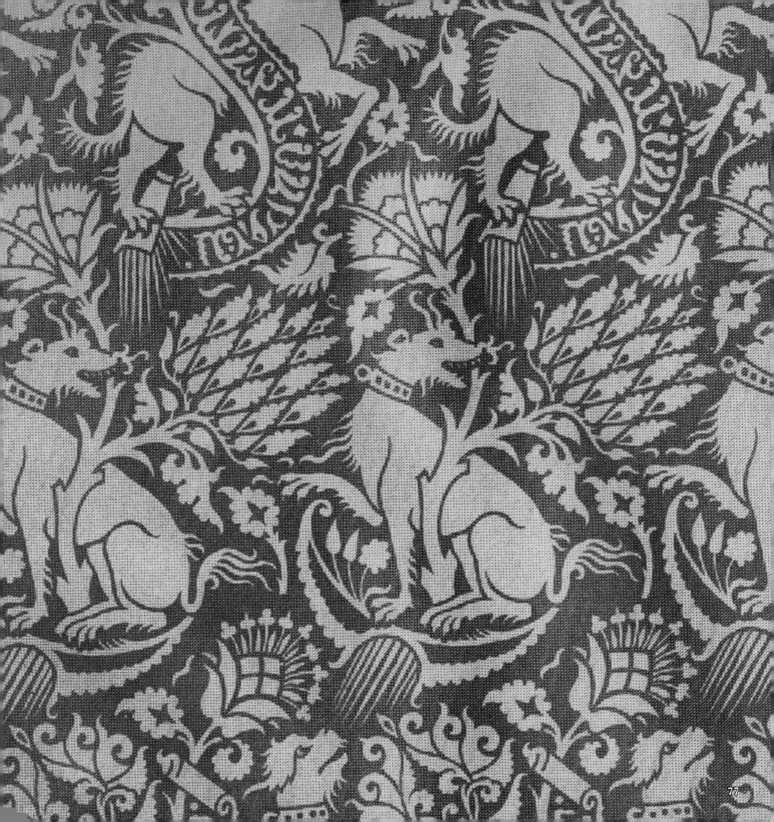

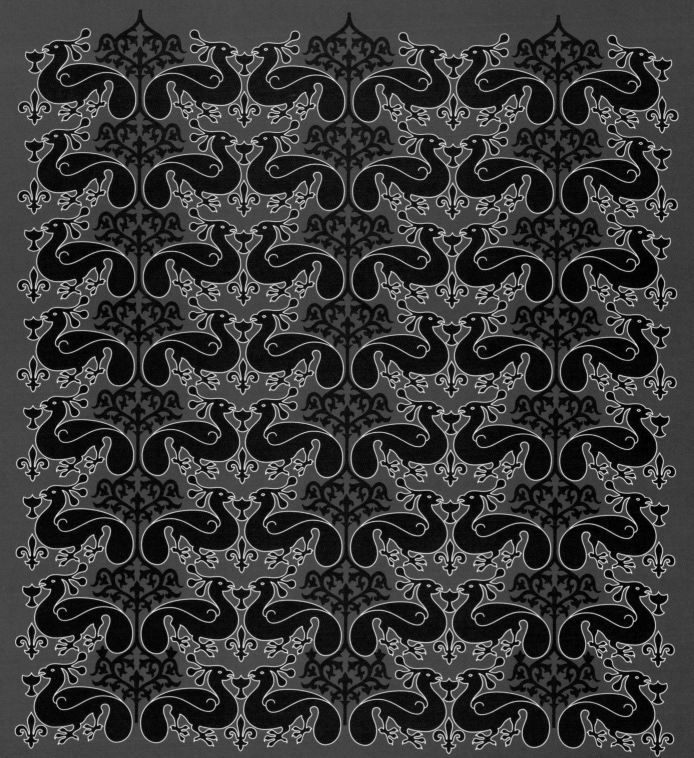

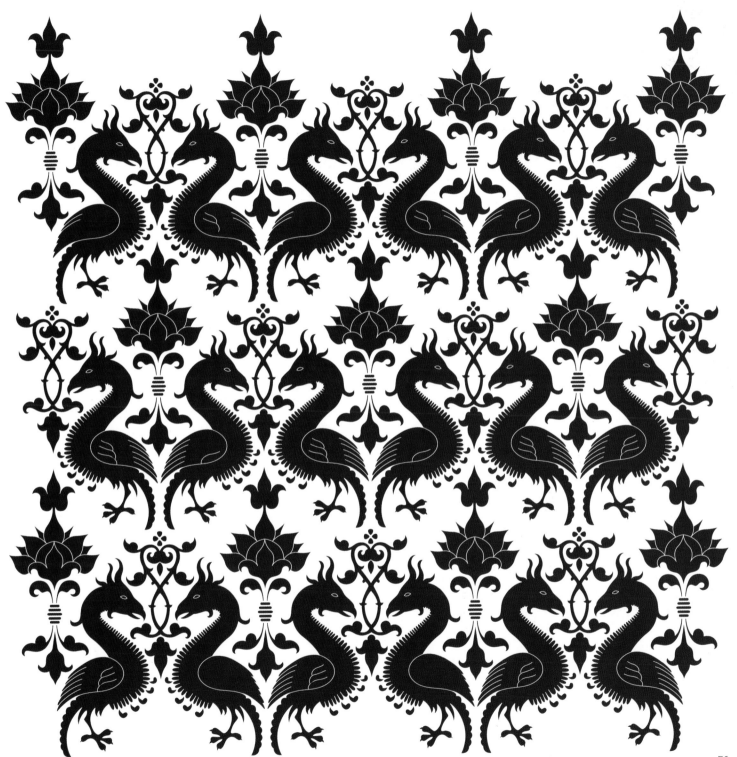

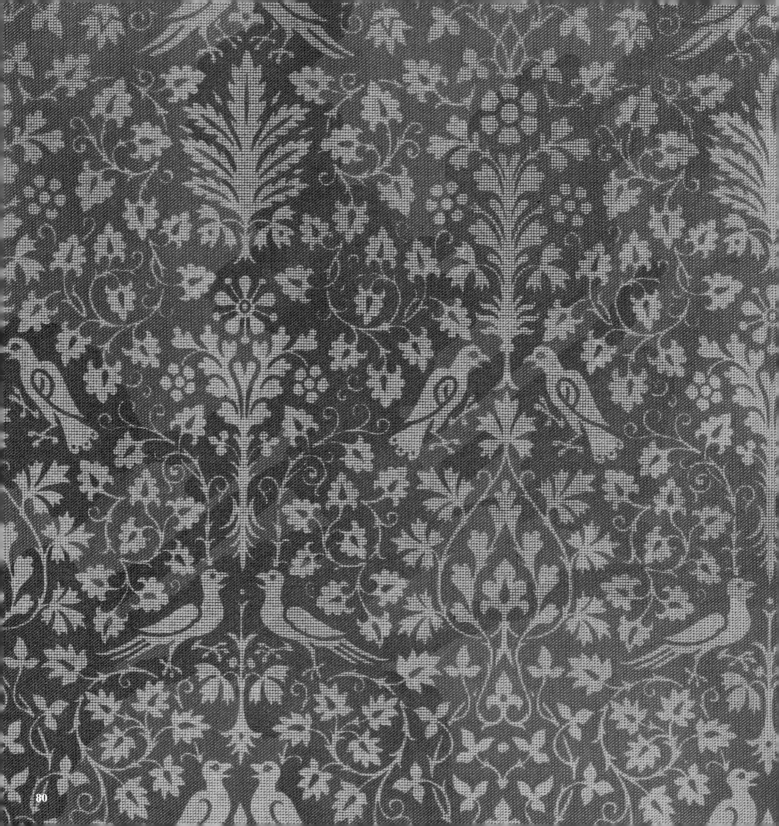

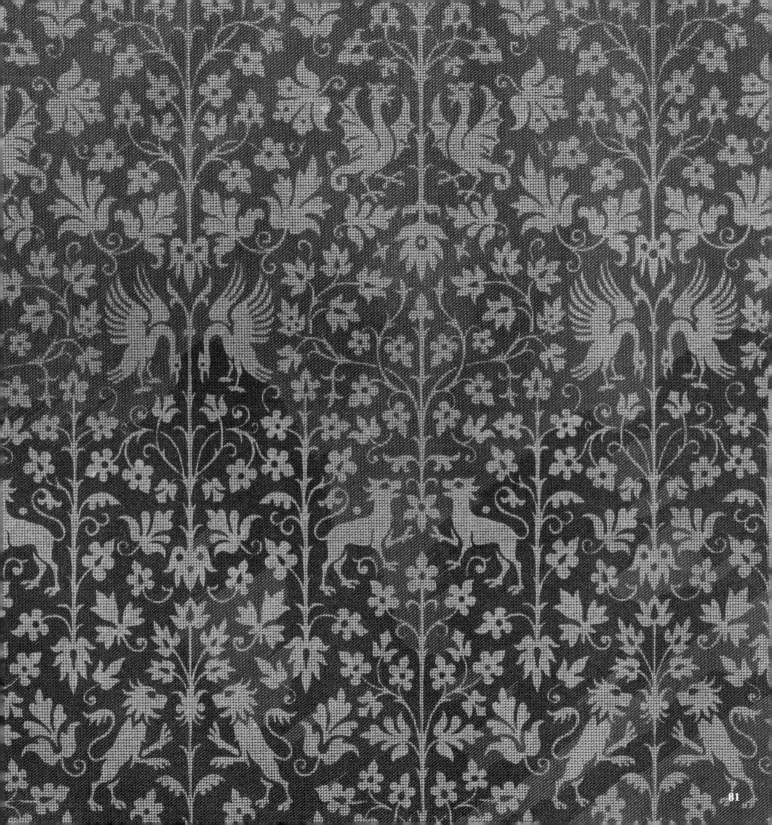

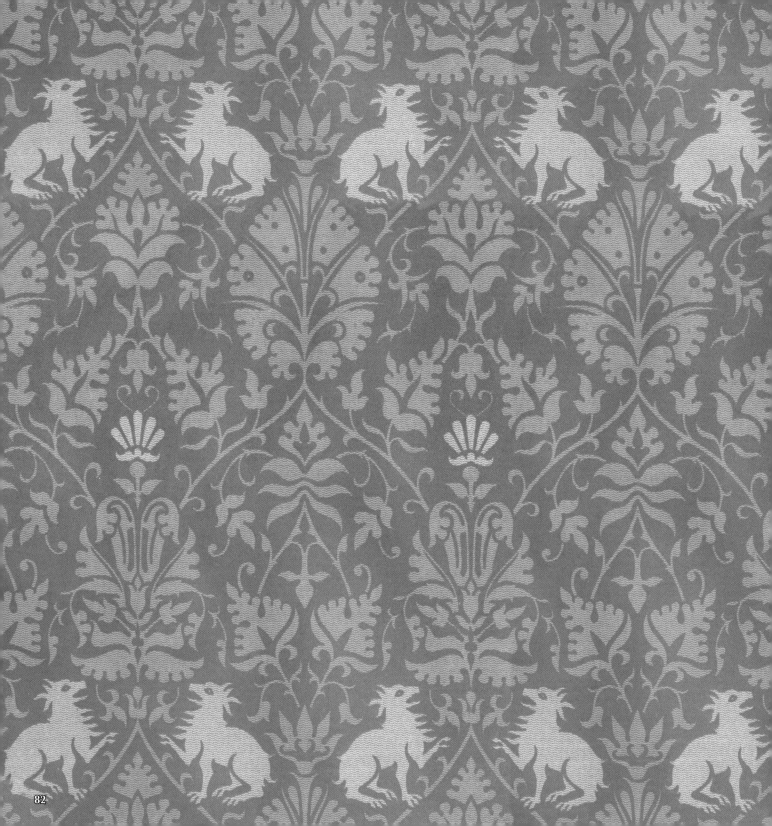

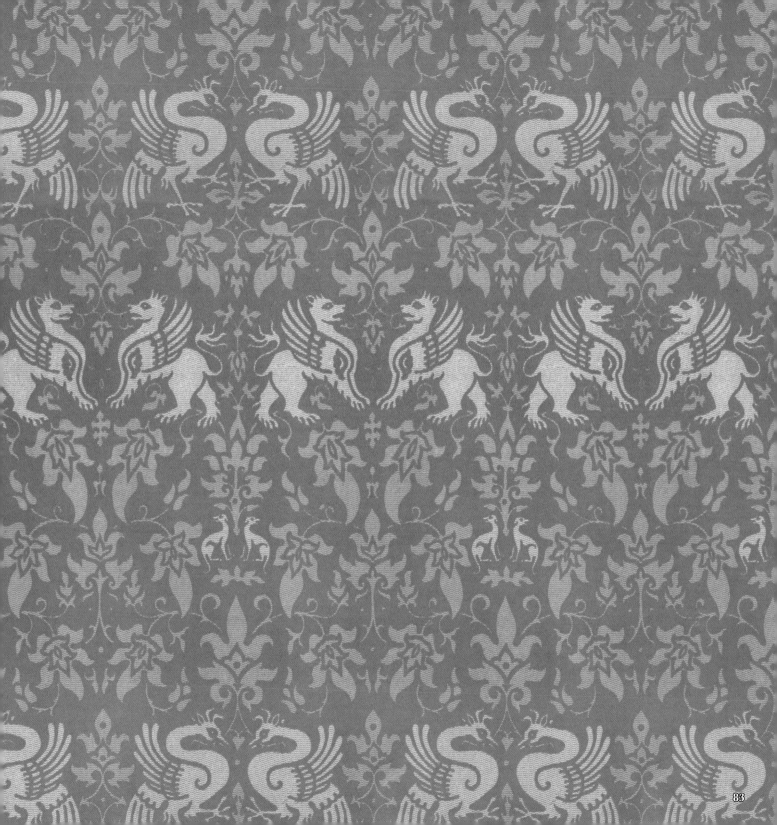

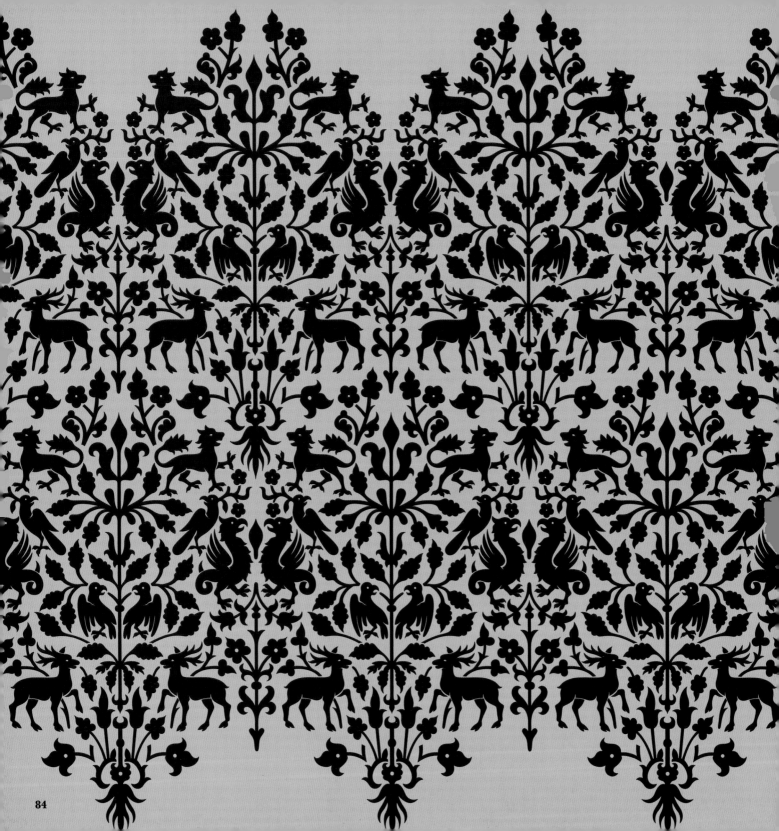

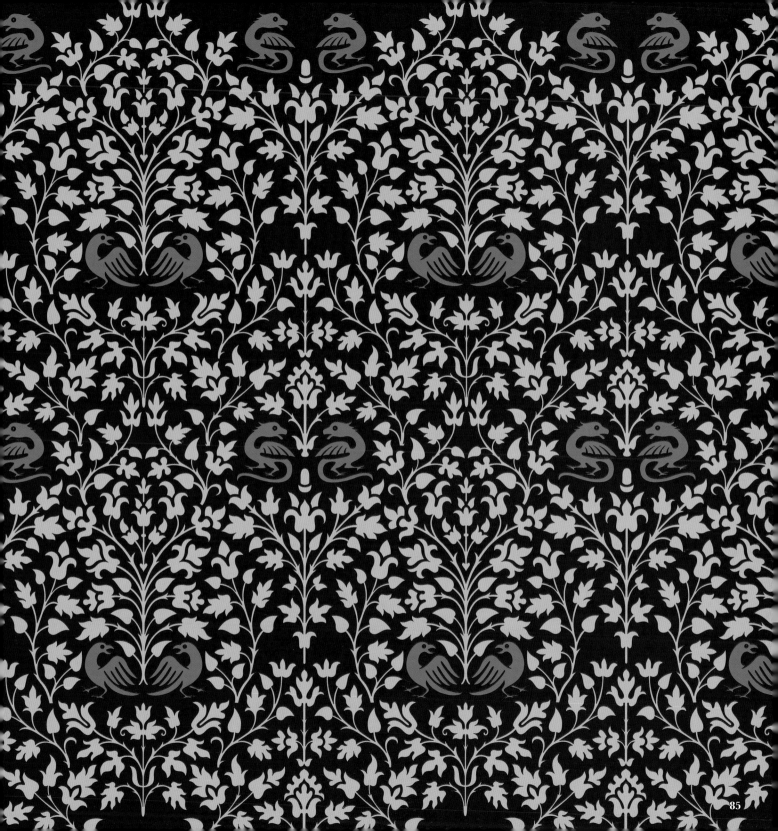

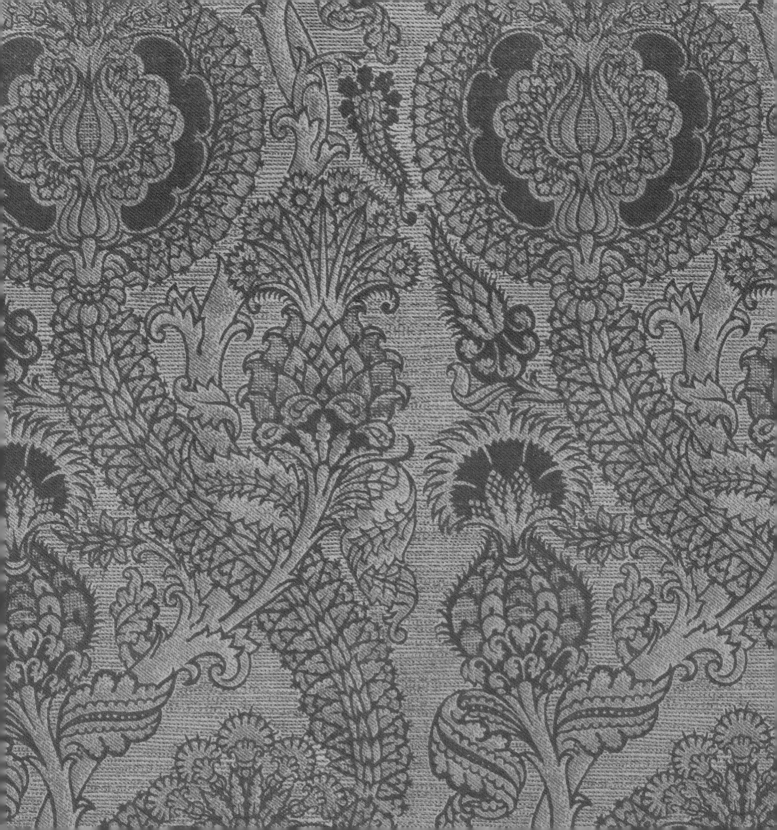

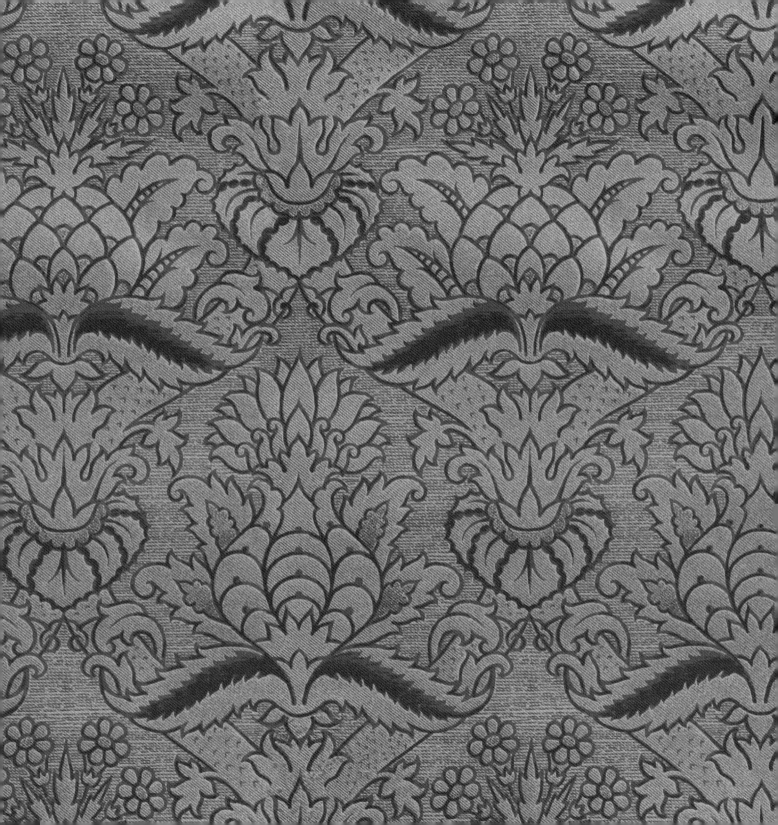

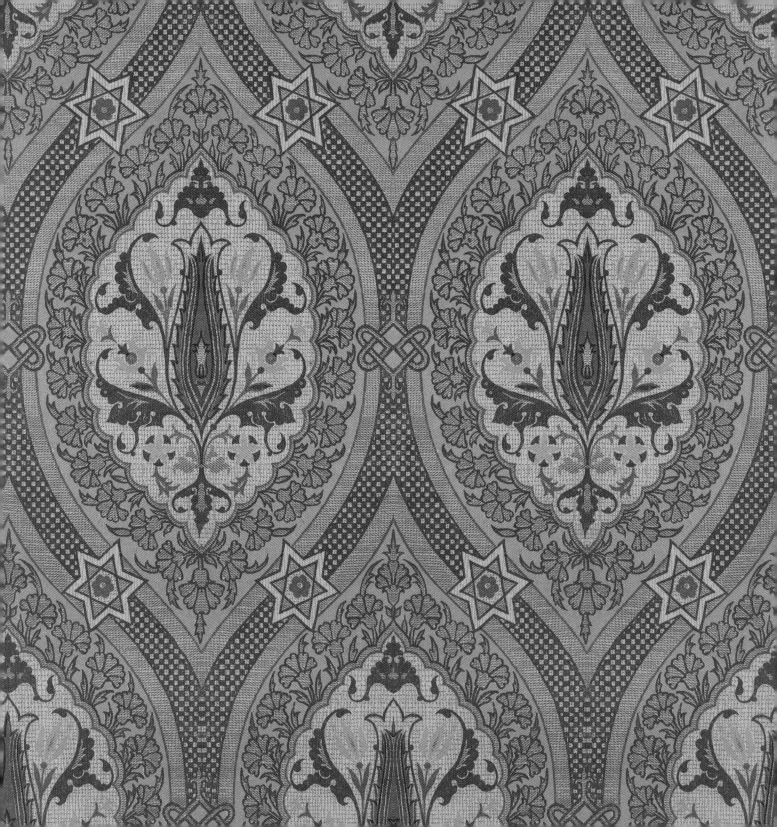

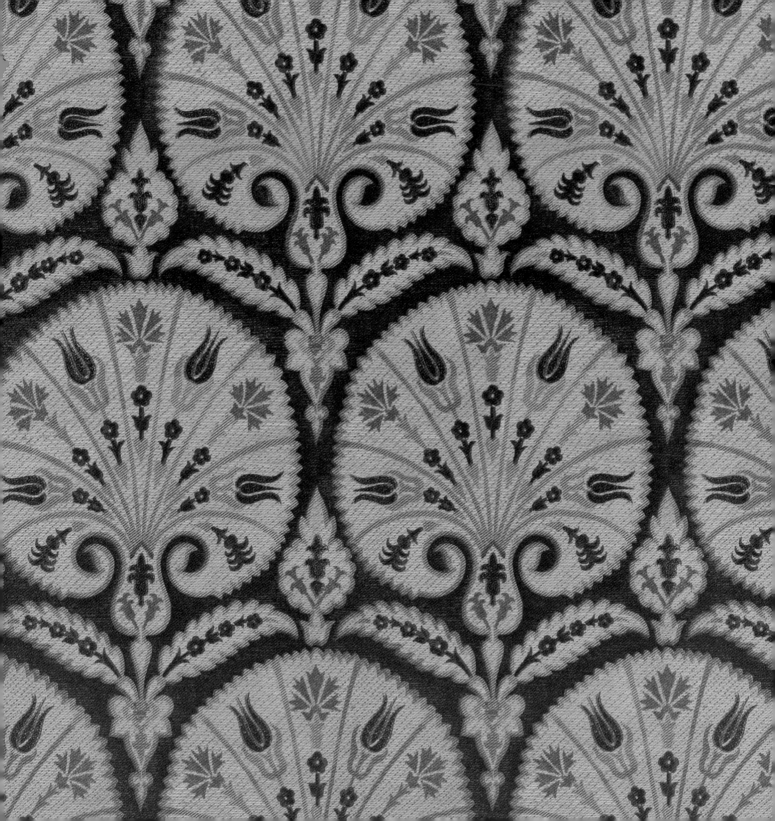

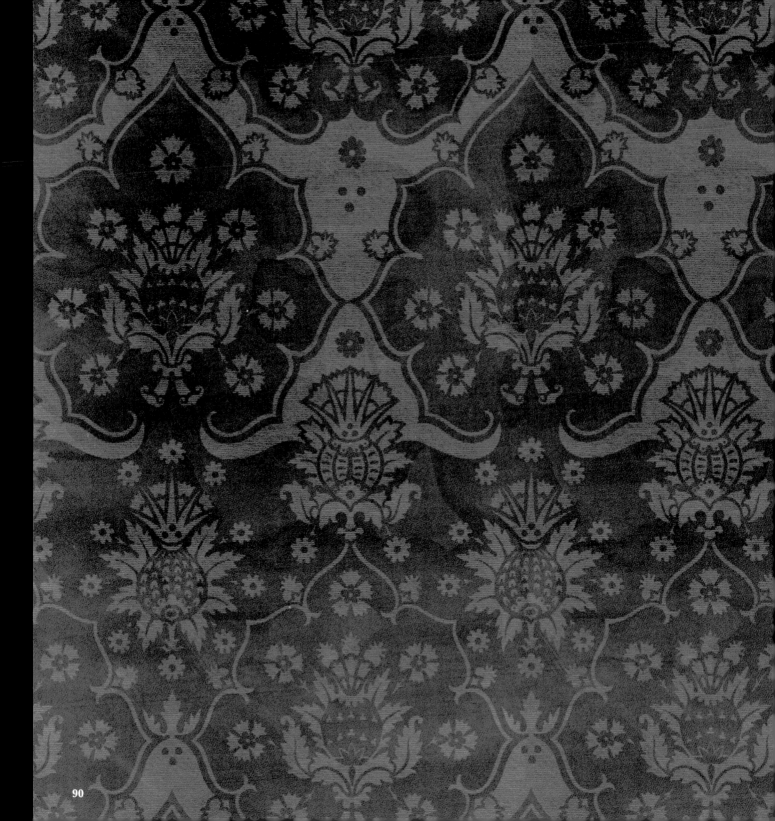

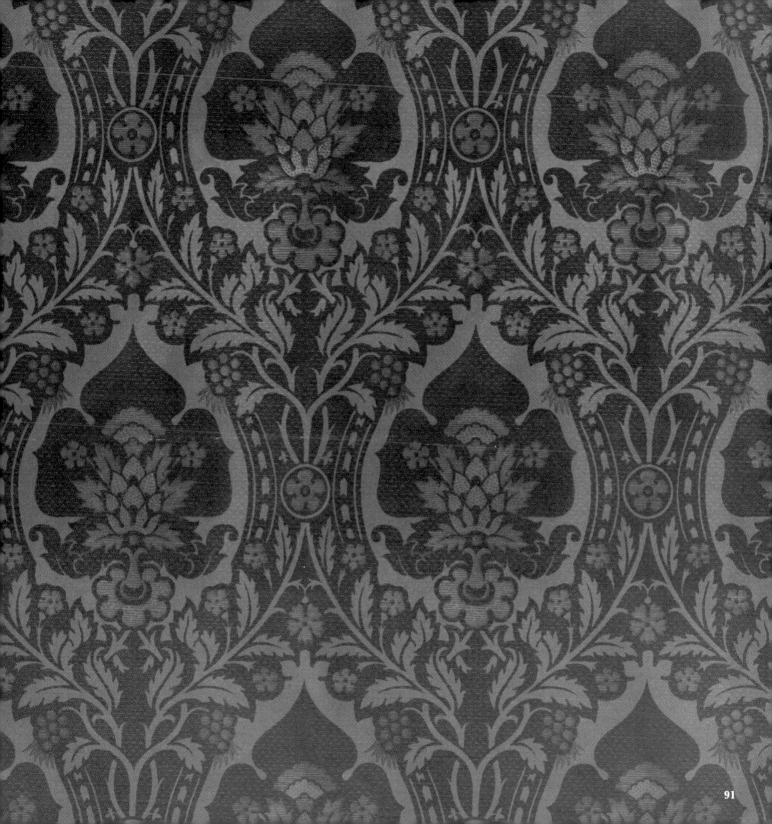

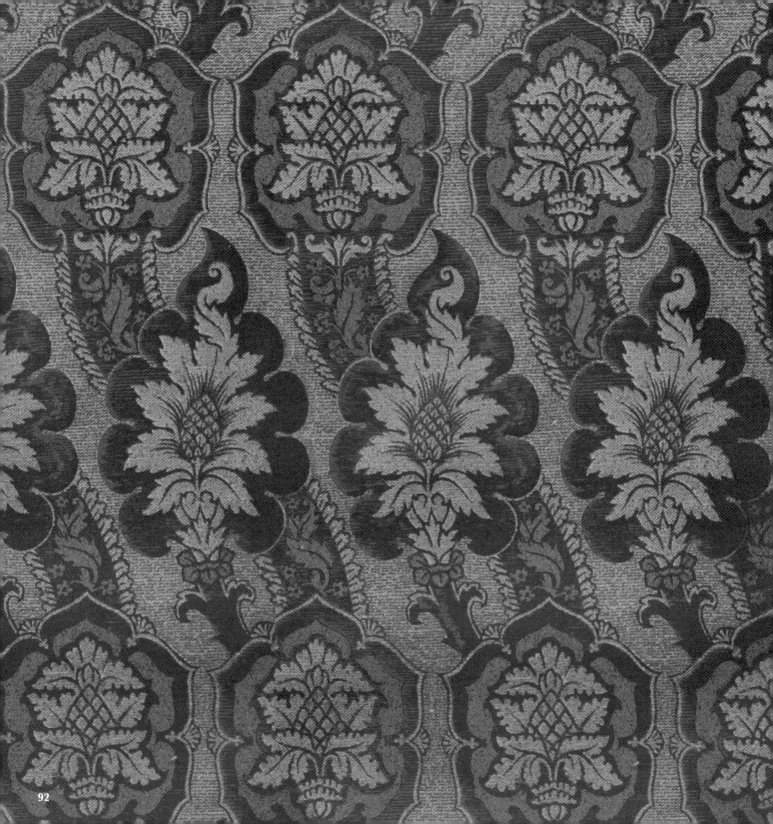

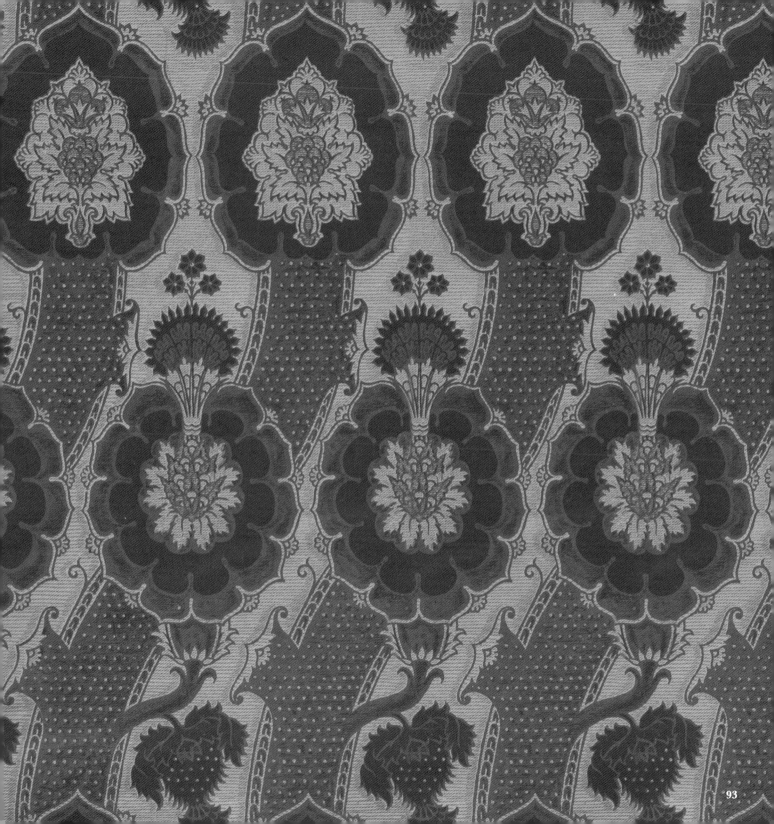

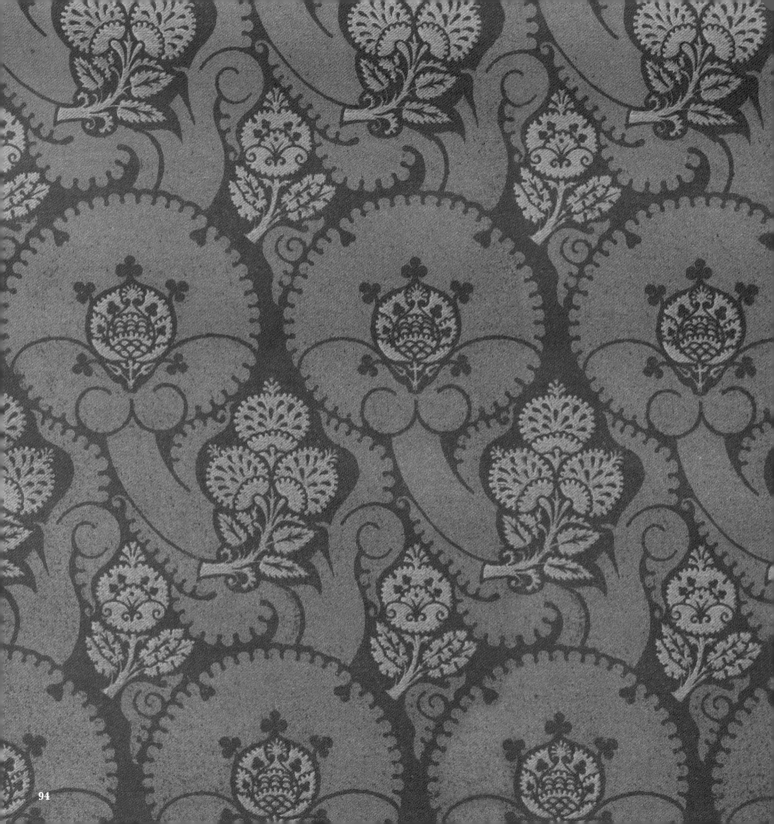

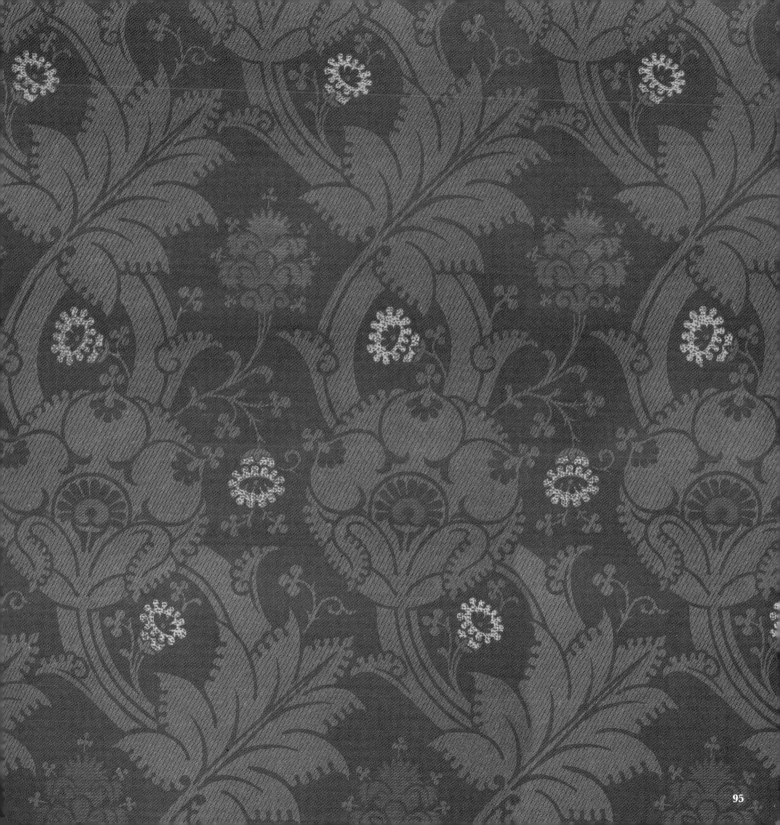

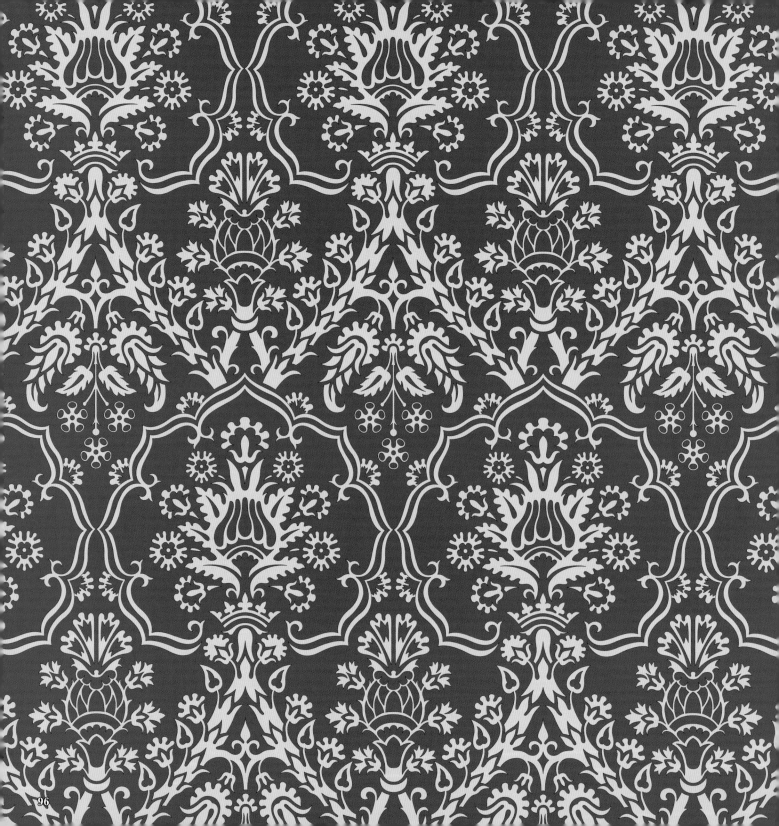

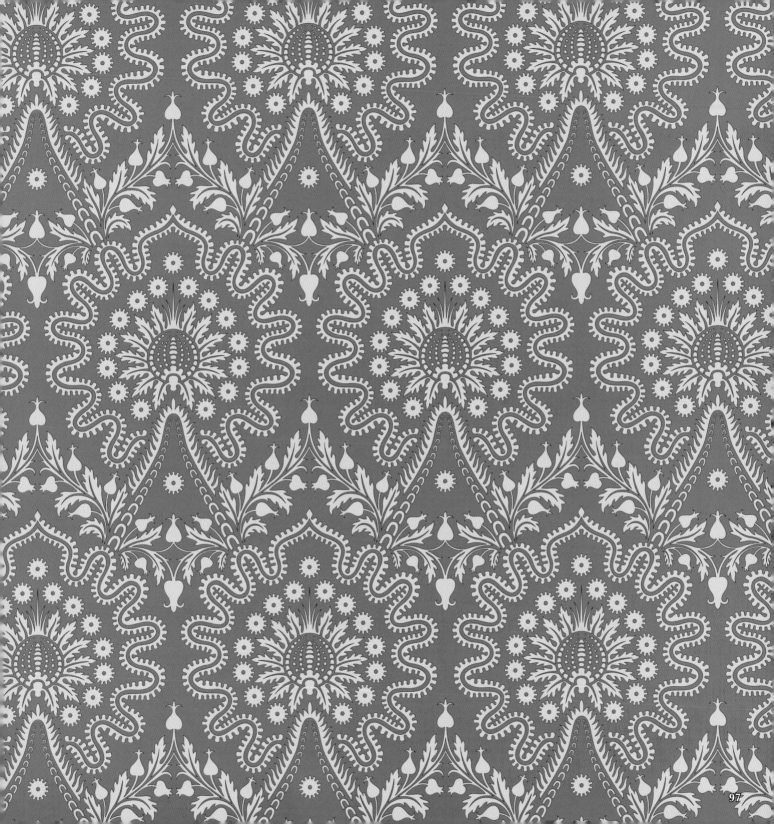

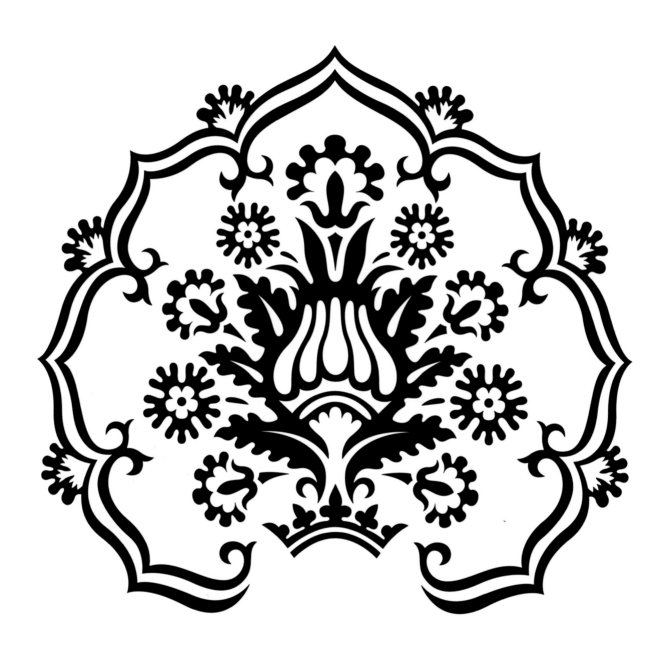

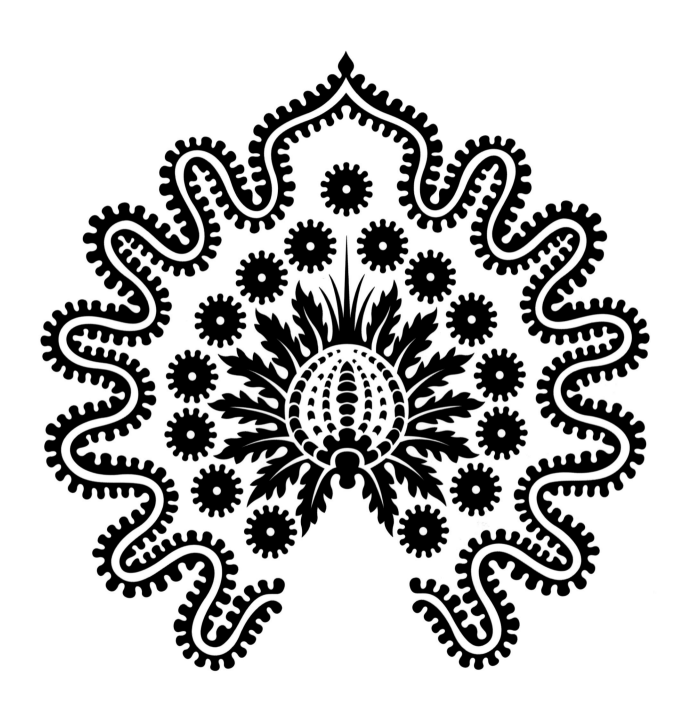

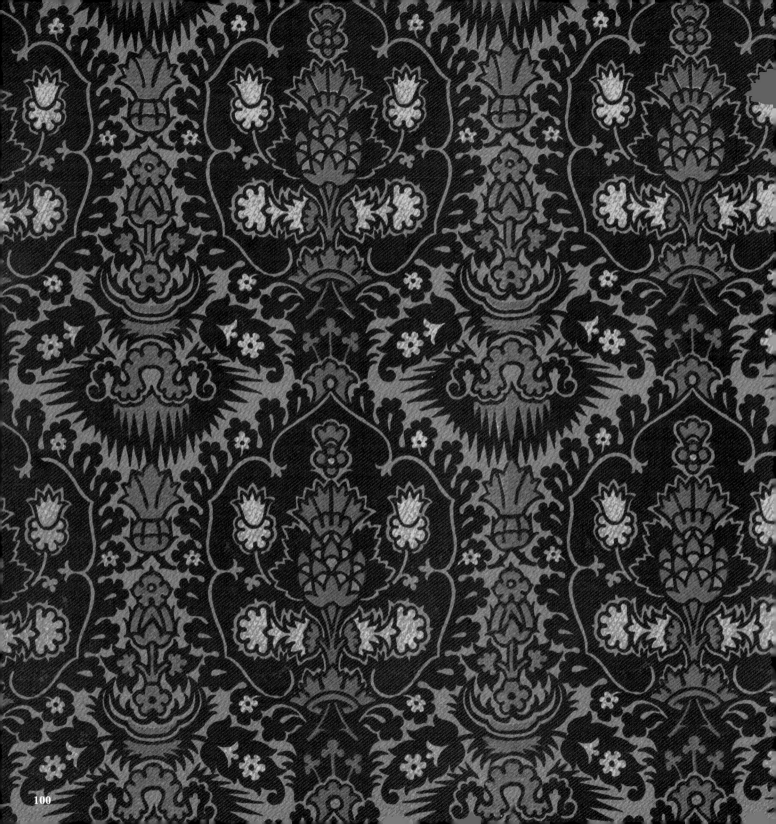

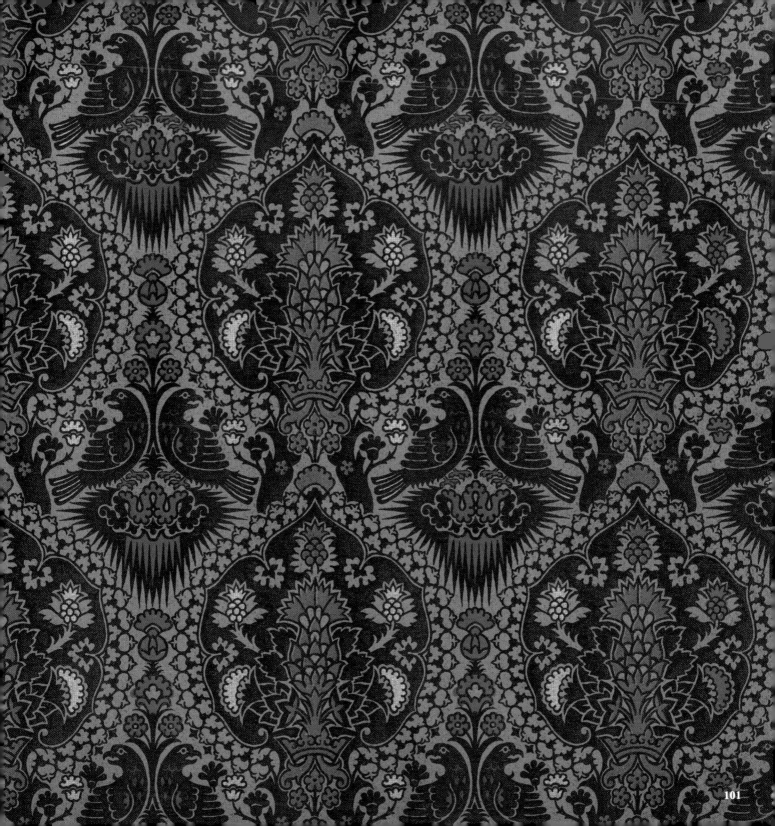

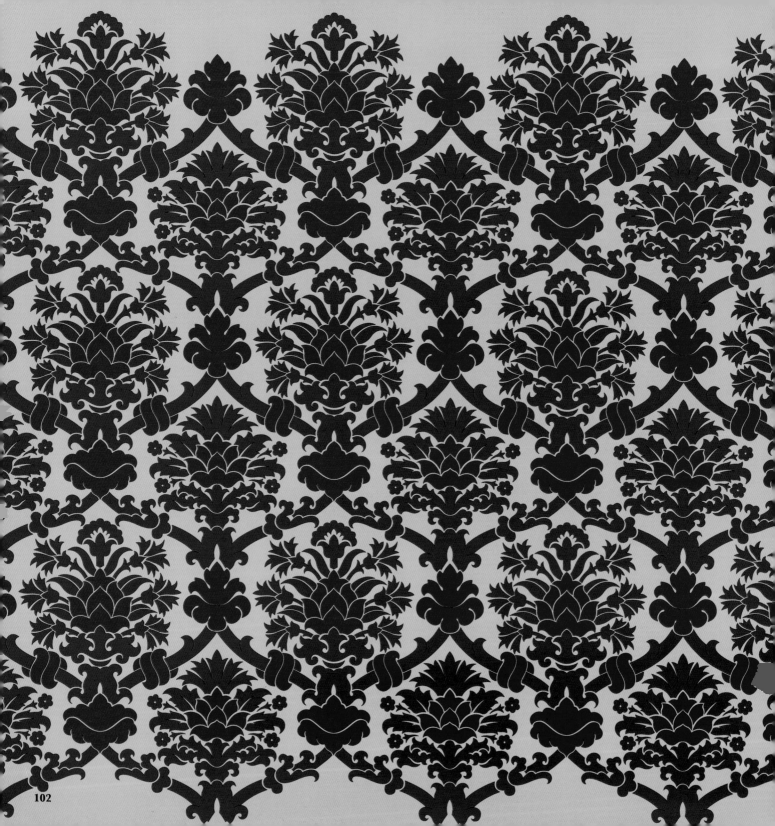

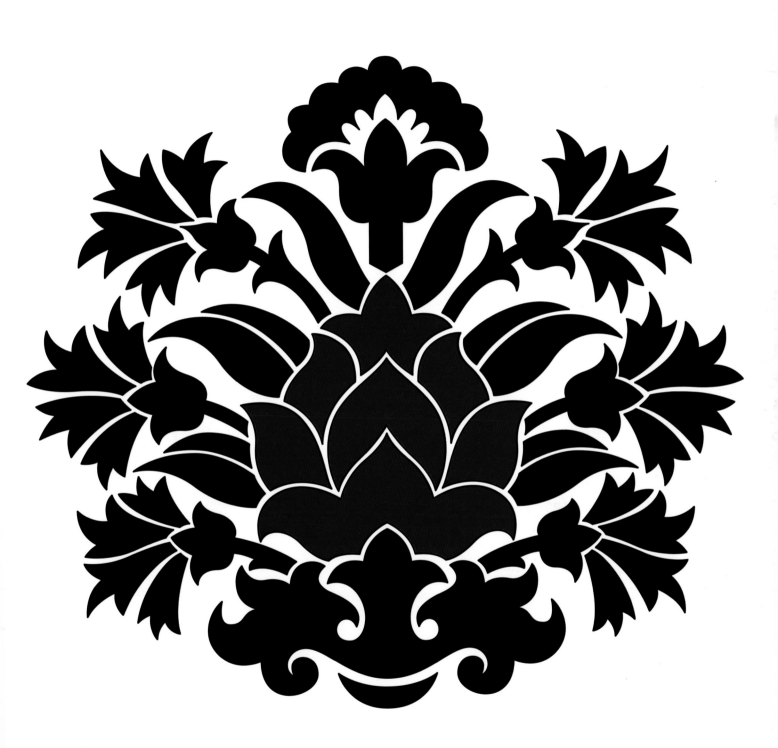

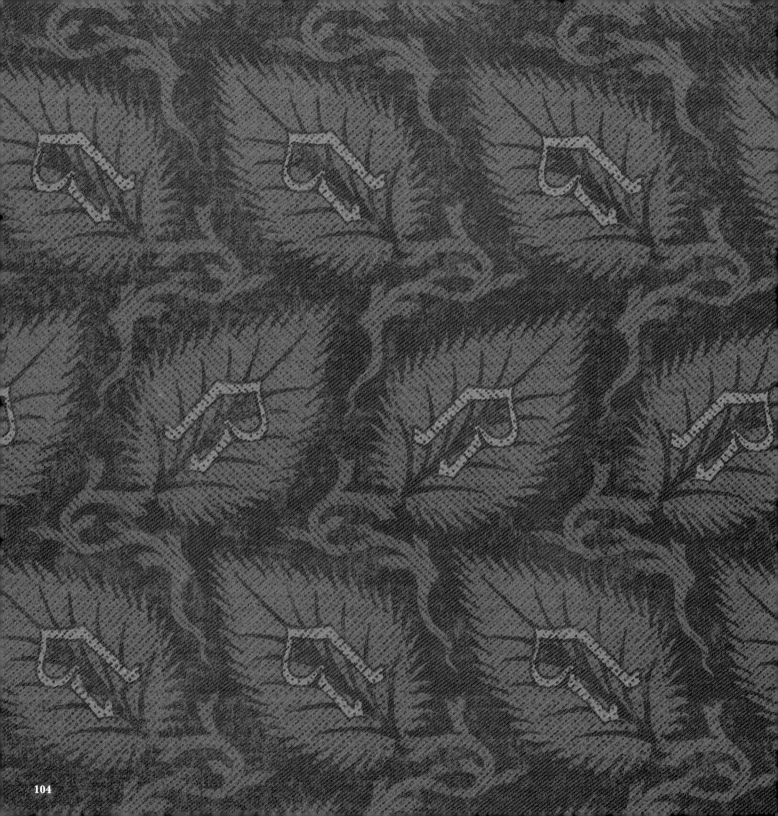

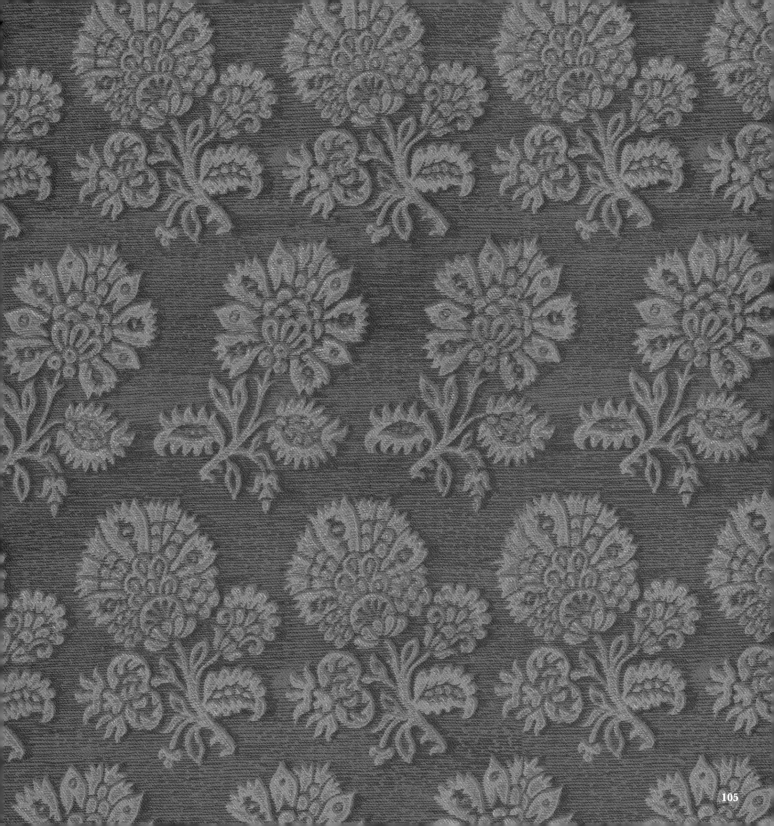

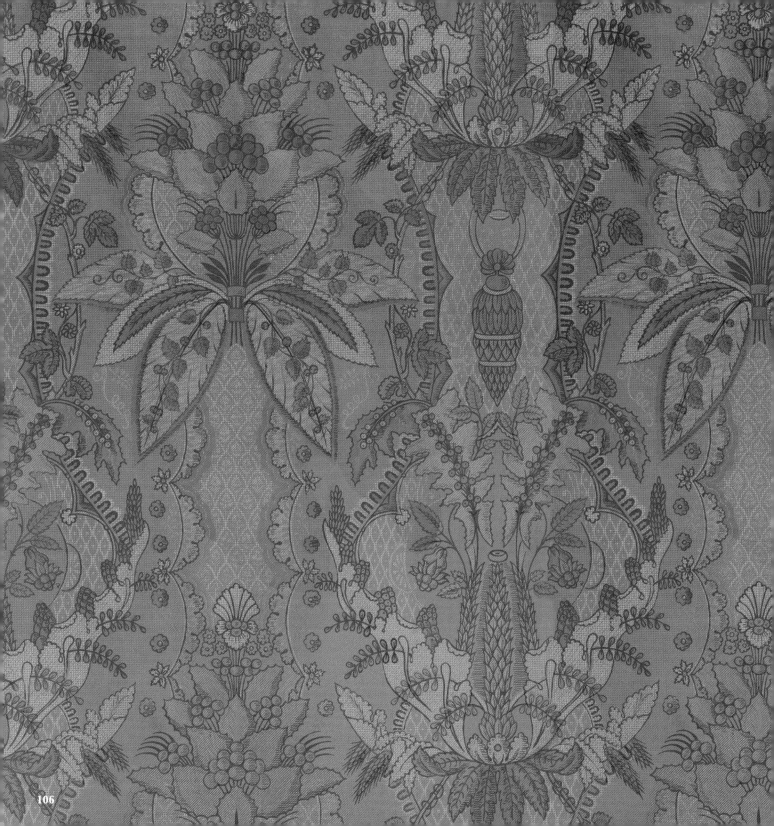

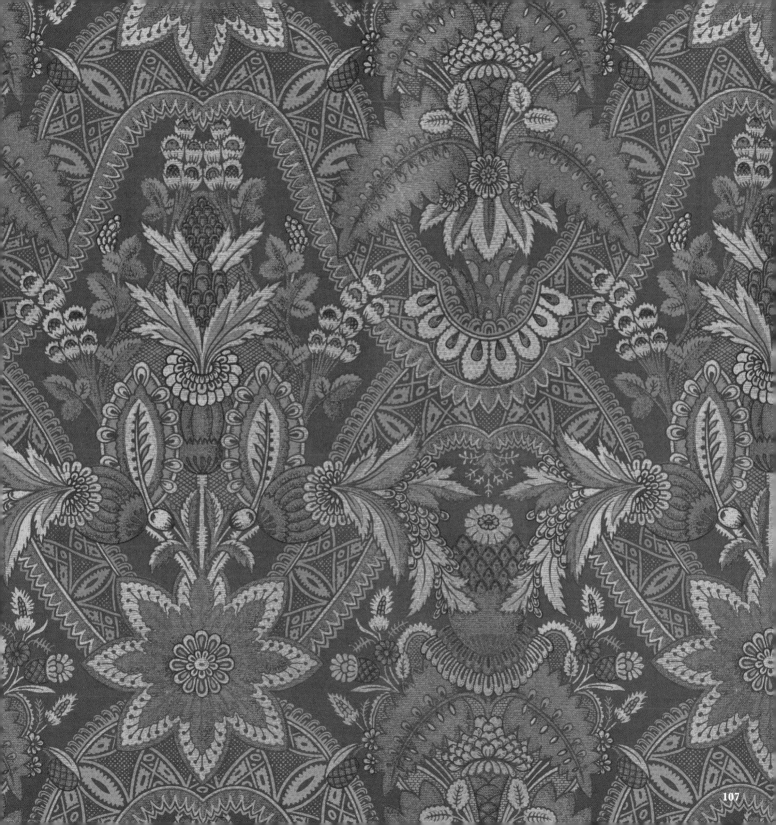

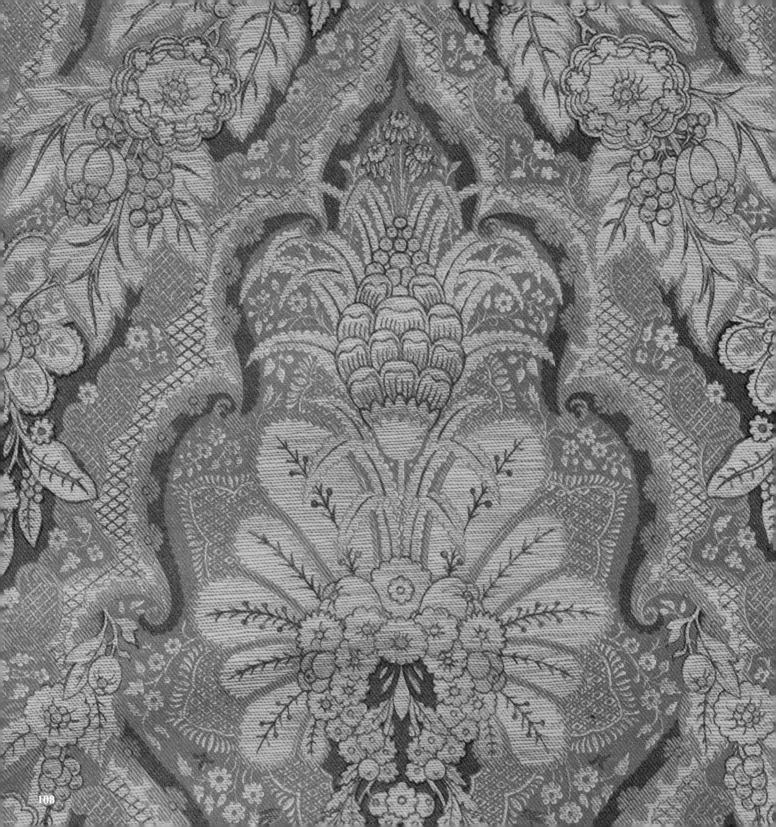

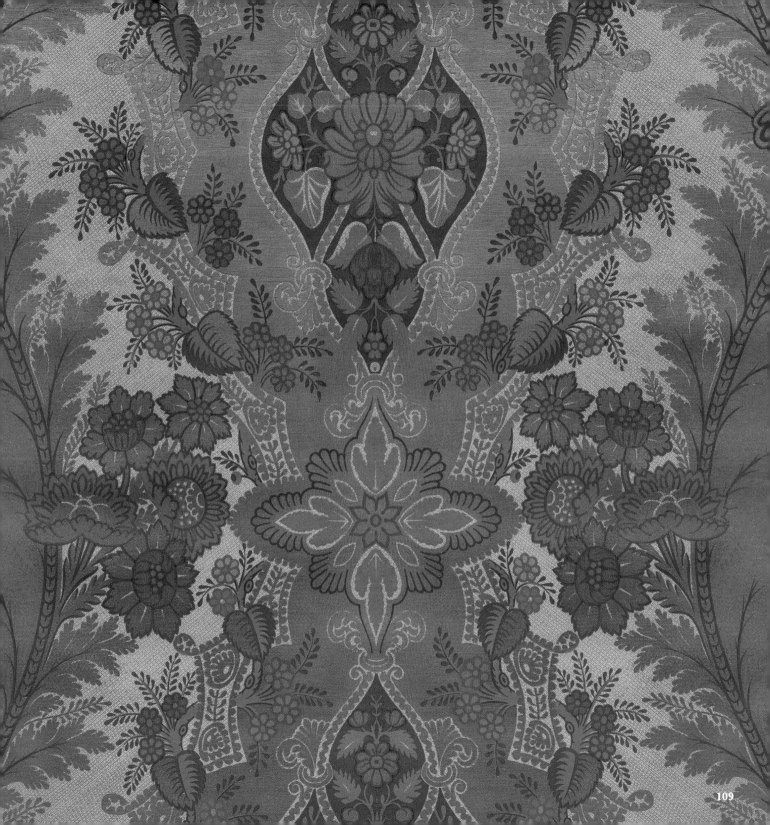

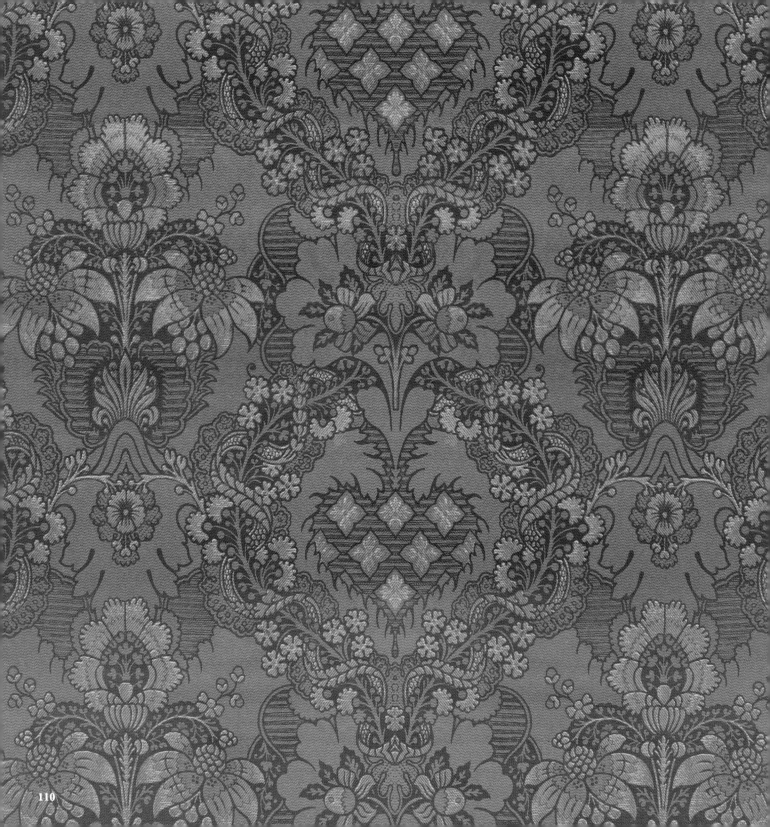

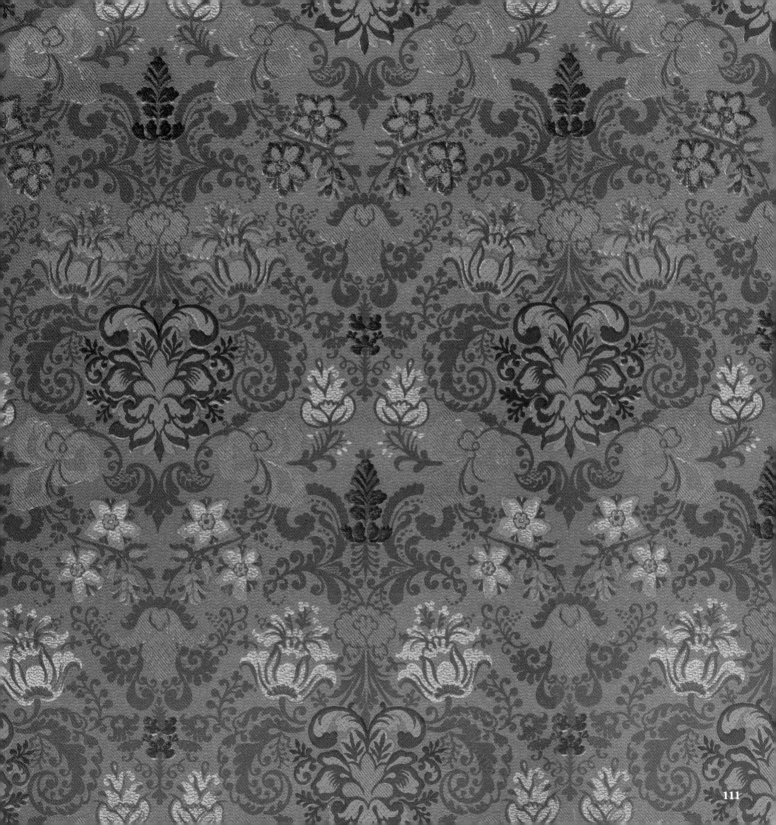

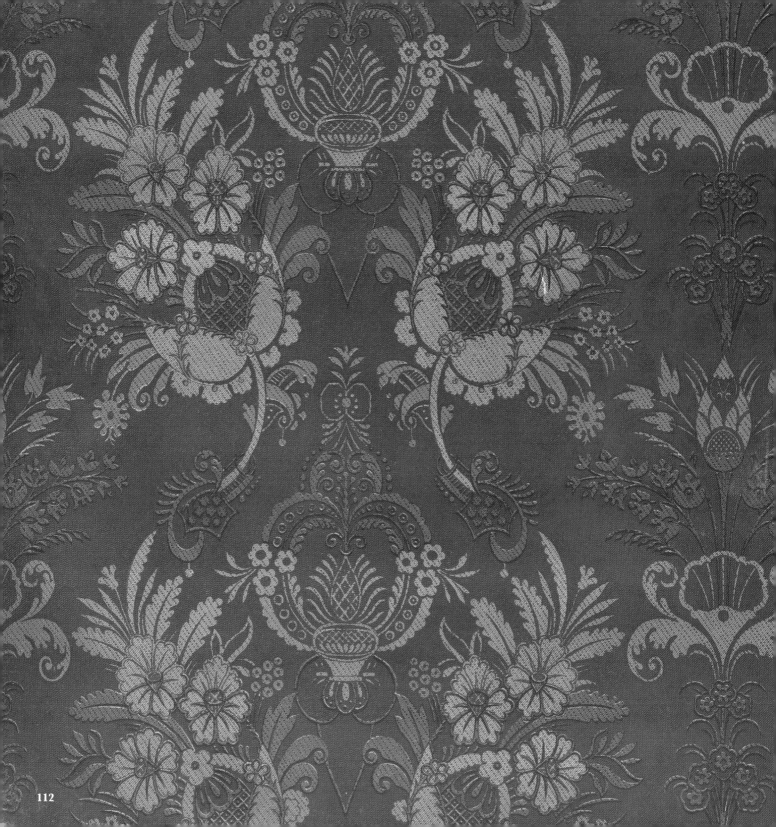